HarperCollins*Publishers*
77–85 Fulham Palace Road,
Hammersmith, London W6 8JB
www.tolkien.co.uk

Published by HarperCollins*Publishers* 2014
1

Cover design by Monique Hamon
Back cover art by Gus Hunter

The Art of the Adventures of Tintin
The Art of District 9: Weta Workshop
Weta: The Collector's Guide
*The Crafting of Narnia: The Art, Creatures, and Weapons
from Weta Workshop*
The World of Kong: A Natural History of Skull Island
The Hobbit: An Unexpected Journey, Chronicles: Art & Design
*The Hobbit: An Unexpected Journey, Chronicles II:
Creatures and Characters*
The Hobbit: The Desolation of Smaug, Chronicles: Art & Design
The Hobbit: Smaug, Unleashing the Dragon
The Hobbit: The Desolation of Smaug, Chronicles: Cloaks & Daggers

Visit the Weta Workshop website for news, an online shop,
and much more at www.wetanz.com.

THE HOBBIT™
THE DESOLATION OF SMAUG

CHRONICLE COMPANION

SMAUG
UNLEASHING THE DRAGON

FOREWORD BY BENEDICT CUMBERBATCH

HarperCollins*Publishers* *wETA*

THANKS

This book would not have been possible if not for the assistance, guidance and grace of the following people...

Peter Jackson, Fran Walsh, Philippa Boyens, Matt Dravitzki, Amanda Walker, Judy Alley, Anna Houghton, Melissa Booth, Benedict Cumberbatch, Nick Gall, Jill Benscoter, Susannah Scott, Elaine Piechowski, Victoria Selover, Chris Smith, David Brawn, Terence Caven, Kathy Turtle, Marta Schooler, Joe Letteri, David Gouge, Amy Minty, Natasha Turner, Inge Rademeyer, Yalda Armian, Diana Godo, Richard Taylor, Tim Launder, and all our many amazing contributors from Weta Digital, Weta Workshop and 3Foot7, listed in full in our credits section at the back of this book.

Sincerest thanks from all of us on the Weta Publishing team.

CONTENTS

JH
WD

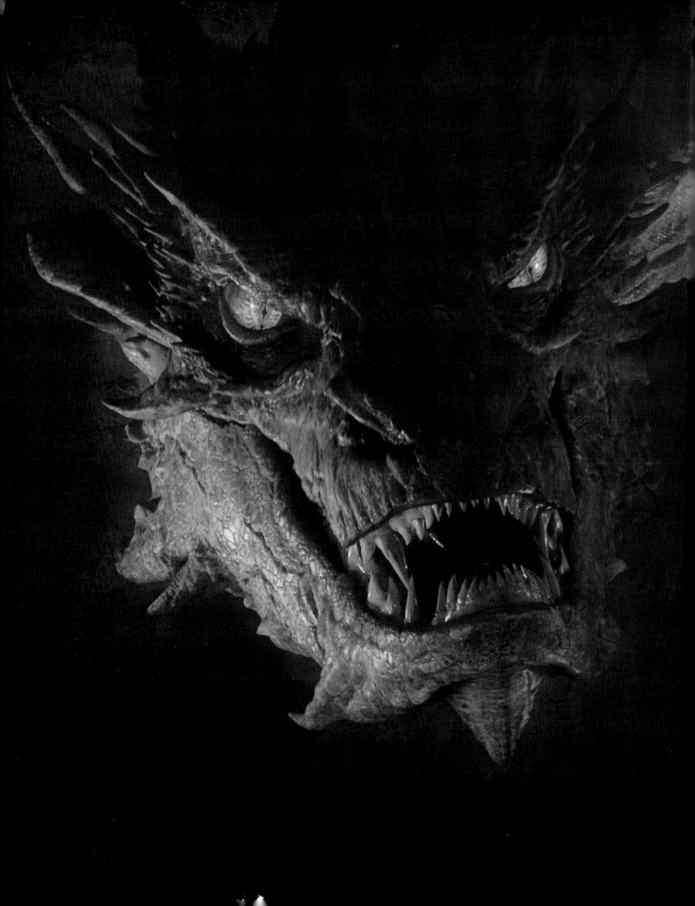

FOREWORD

Smaug was a rich part of the tapestry of my upbringing. My father read *The Hobbit* to me, a chapter a night, when I was a boy, and being the extraordinary actor that he is, he introduced all of the characters with full vocal performances, including an incredible Smaug. Thanks to him, J. R. R. Tolkien's world lived in my imagination with a vivid reality, and his Smaug formed the base upon which I would build my own interpretation of the character decades later when I had the good fortune to join Peter Jackson's amazing team on his adaptation of *The Hobbit*.

In a case of poetic synchronicity, I was born in the Chinese Year of the Dragon and it was the Year of the Dragon again when I started work on the films. What meaning that has, I am not sure, but it does serve to exemplify the point that people everywhere ascribe qualities to Dragons beyond being simply objects of dread, which Smaug most certainly is. As part of my research, obviously I went to a zoo and studied those animals that replicate something of how Smaug might behave in his fantastical setting, but I also thought about what Dragons mean to our culture and why they are a symbol of great power, prowess and pride.

There is, of course, nothing benign about Smaug. Along with his pride, anger and avarice are his other great stumbling blocks. He is so physically powerful and seemingly invulnerable, yet these emotions are all too human and level the playing field, making him vulnerable on a human level, or a hobbit's. I wanted that to be evident in how he comes into a situation where he's in complete control then his vanity, his ego, completely gets the better of him, making him vulnerable in that moment to an act of heroism.

People should be attracted to Smaug's power, because he *is* awe-inspiring, but there is also a caveat. Dragons are symbols of power and objects of awe, true, but they are also talismans warning us of the destructive force that power brings, of how power can also destroy its wielder. It is a very strong message in Tolkien's stories. Power is to be respected and harnessed toward an express purpose that has benefit beyond the self. If it exists only for its own end then it is evil. It is entirely to be expected, and indeed hoped for, that people should be attracted to Smaug's power. They might even envy him, but they should also witness what that power has created and take heed that, in that moment, they too were seduced and ensnared by the same power that has corrupted him.

This book tells the story of the grand collaborative endeavour that was undertaken to render Smaug in vivid cinematic reality. The reader will, I hope, be awed and seduced by the Dragon and the industry of his creation just as I was by my father's skill when he brought Middle-earth to life for me. But I hope the reader also comes away with an appreciation for why such effort was necessary and what the ultimate goal of it all was. This is not a celebration of the destructive majesty of the Dragon, but a rich and powerful illustration, by way of dramatic contrast, of the understated heroism of the story's true star, the humble hobbit Bilbo, whose wholesomeness of character ultimately saves his world.

Benedict Cumberbatch, Smaug

CONCEPTUALIZING A DRAGON

J.R.R. Tolkien's book of *The Hobbit* has had such an impact during its seventy-five years that, for many people, Smaug is the Dragon of our imaginations. During those intervening years we've been exposed to so many other Dragons on screen that when we began working on these movies it put us in a complex position as designers wanting to honour the iconic tradition while still offering something fresh. We were designing the granddaddy of western Dragons. He ought to be the classic, iconic Dragon, but could he just be that? We tried to steer around other cinematic Dragons, but stray too far and Smaug could risk looking alien and jar with what Tolkien described.

Paul Tobin, Weta Workshop Designer

To begin with we were looking for ways to give Smaug surprising or transformative elements. I offered some ideas with multi-hinged jaws and unfolding, brightly coloured gill-like sections that I rationalized as perhaps being heat regulators or serving a display function among Dragons.

Christian Pearce, Weta Workshop Designer

DF
WW

WETA WORKSHOP

◁ ▷

The Weta Workshop design department, managed by Richard Athorne, was involved at the earliest conceptual stages to design creatures, armour and weaponry for the films. On Smaug this also involved working alongside Alan Lee and John Howe, and it was a very enjoyable period of blue-sky dreaming, pitching all kinds of wild and varied suggestions for how the Dragon might appear. Our designers used traditional drawing and sculpting as well Photoshop paintings and 3D ZBrush models sculpted entirely on the computer as we honed our concepts according to Peter's vision.

Richard Taylor,
Weta Workshop Design & Special Effects Supervisor

CONCEPT ART DIRECTORS

◁ ▷

Alan Lee and I have been doing essentially the same thing for the last four years: providing imagery for *The Hobbit*. The work is always the same, although the purpose varies considerably; from the very first concept sketches to adjusting fine details in the final version of a given scene, we are always striving to achieve the same thing: create a Middle-earth familiar but nevertheless vast and varied, and try to maintain an overall artistic vision.

John Howe, Concept Art Director

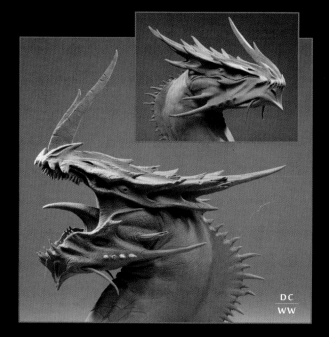

DC
WW

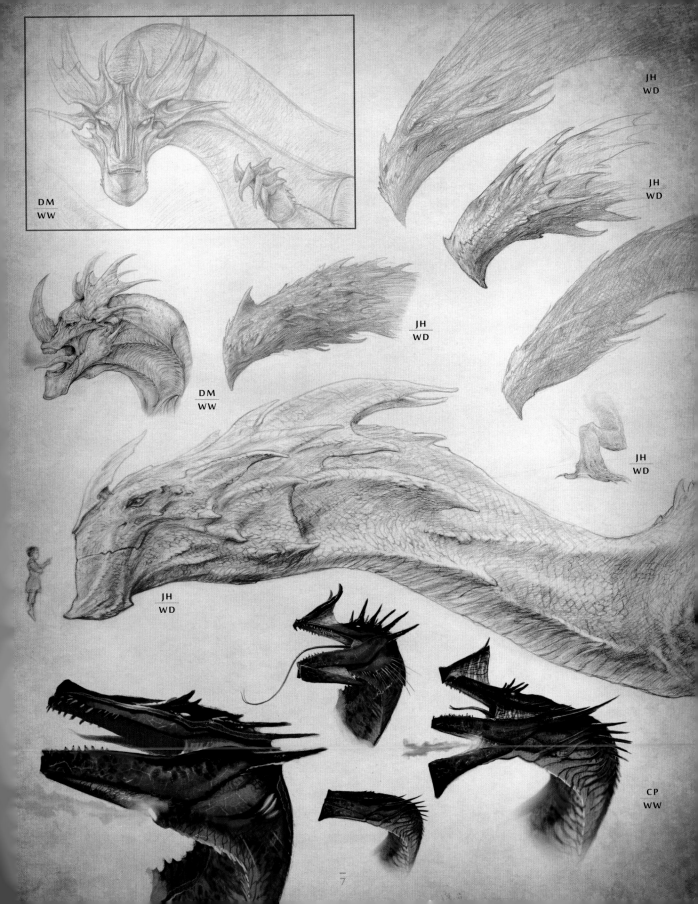

DM
WW

JH
WD

JH
WD

JH
WD

DM
WW

JH
WD

JH
WD

CP
WW

7

Smaug is the quintessential fantasy Dragon to our generation, so my first drawings started out safe, based in conventional sea horse and crocodile-inspired ideas, then gradually moved in less familiar directions in the quest to find an individual identity and personality for him. I really liked the idea that Smaug was very grand and impressive, but look too closely and you see the decay and filth. He is an evil creature, born of the Dark Lord Morgoth's corruption, so I thought of him as a manifestation of power, gluttony and riches – he looks great from a distance but get close and the appeal quickly dissolves.

Daniel Falconer, Weta Workshop Designer

DF
WW

Feathered dinosaurs are so cool, so what about a feathered Dragon? I liked the hint of vanity that came with a head crested with huge, colourful plumes, plus it's surprising and slightly unsettling on a huge reptile, but I was way off the mark! At this point Peter was looking for something more like a big winged Komodo dragon, so that ruled out elaborate horns and adornment.

Daniel Falconer, Weta Workshop Designer

In addition to heavy folds and lots of hanging skin under the neck, I put as much age into the expressive areas of my Dragon concepts, such as around the eyes, as I could. Looking at Komodo dragons and large monitor lizards for inspiration, I included a hunch behind his neck and some spikes to help give him more presence and attitude, with a few fantasy elements sprinkled in.

Gary Hunt, Weta Workshop Sculptor

I thought it might be cool to have a bony feature on Smaug's head suggestive of time spent pushing through tunnels and rocks under the Lonely Mountain. Thinking about his wings too, I imagined they would have to be absolutely massive to believably lift him, but then they'd also have to be capable of tucking very tight to his body when moving about in Erebor.

Lindsey Crummett, Weta Workshop Designer & Sculptor

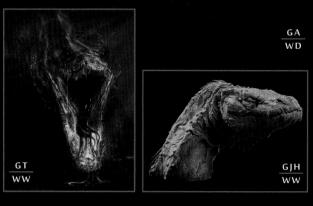

In some of his first feedback, Peter suggested Komodo dragons for inspiration. They have an age and weight that recalls pre-dinosaur reptiles and hinting at antiquity, though it's hard to imagine some of our early Komodo-esque concepts flying. Making Smaug six limbed, as in the book, also presented some mechanical challenges. I raised the shoulders and tried to get them out of the way so there would be room for the huge muscle connections a creature like this would need, with the hinge quite low down in his chest.

Christian Pearce, Weta Workshop Designer

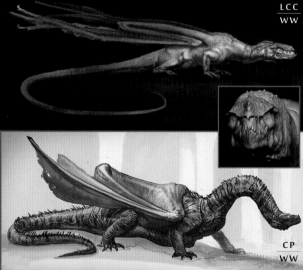

Going for something more fantastical, another of my early concepts was a Smaug bust that had a collection of small wing-like structures on his head *(below, right)*. I imagined they would be articulated and have membranes. They would spread out when he flew or might be indicative of his mood. Maybe they'd bristle like a cat's whiskers, flaring up or sticking right out depending on which emotion he was expressing, creating some really interesting, changing silhouettes. I also gave him an external ear, nestled in among the fins, which is something that reptiles don't have, but which would help him appear more Dragon-like as opposed to merely reptilian.

Jamie Beswarick, Weta Workshop Designer & Sculptor

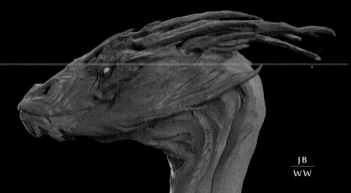

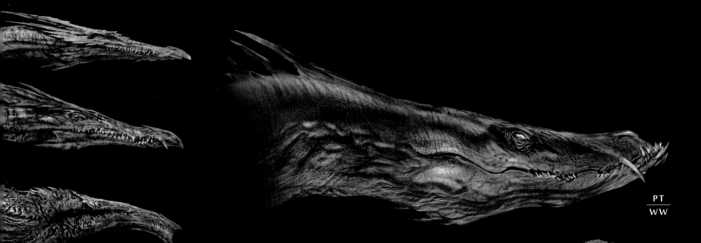

PT
WW

Initially I concentrated on head studies of Smaug, exploring a wide range of different shapes and silhouettes. My first concepts were varied *(left)*, but as Peter reacted to some of the designs by Jamie Beswarick and Greg Tozer I pulled in behind them and followed the lead they had established *(above)*.

Peter talked about Smaug perhaps being quite sinuous. We all love that little line art Dragon that Tolkien drew above the Lonely Mountain on his map. I think everyone was secretly pushing in that direction with their Smaug concepts. It offered such a great point of difference from all of those other Dragon films and while Smaug is the archetypal fantasy Dragon we also had to find a fresh way of doing that which was iconic and faithful, but distinct from everything we've seen before. We were collectively pretty hot on pushing for more of a worm-like Dragon and that definitely drove some of the early conceptual work.

Paul Tobin, Weta Workshop Designer

MA
WW

DC
WW

AK
WW

PT
WW

DC
WW

AK
WW

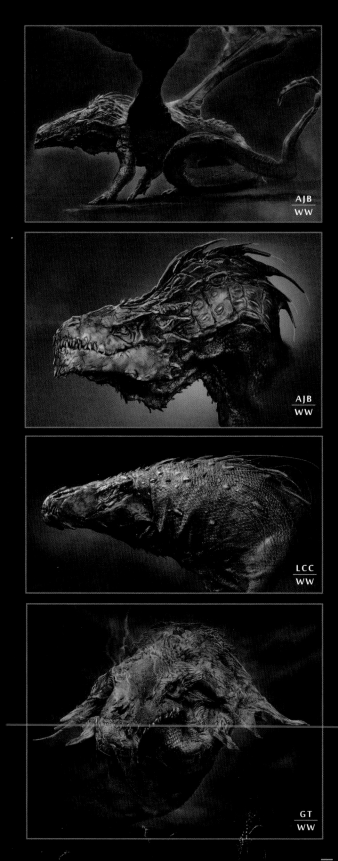

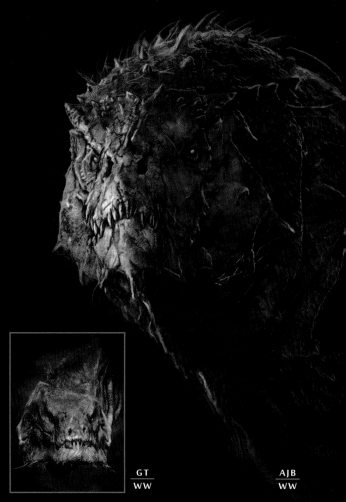

Peter responded well to the concepts in which Smaug looking aged, with cracked lips and sunken eyes. I think the Komodo dragon direction really helped with the design of Smaug's character. Komodos have long torsos, short powerful limbs, and a feeling of mass about them that helped us find a reality in which to ground this fantasy creature.

Andrew Baker, Weta Workshop Designer

In addition to the big lizard lead we were pursuing, I had been looking at vipers. The lower jaw was bigger and quite serpentine with a high line at the back of the 'smile' that Peter liked the idea of. I tried to convey a lot of aging through deep skin folds and heavy wrinkling. There were also areas of decay, where the skin was breaking and the gums receding, exposing more teeth, which added both age and savagery. Tiny teeth and narrow, slitted eyes helped emphasize his massive scale and sly character.

Daniel Cockersell, Weta Workshop Sculptor

I thought of Smaug being like an anaconda, powerful and muscular, with a naturally coiled neck. I wanted to explore the serpentine quality of the Dragon. I could imagine his tail and the body slipping through the gold almost like it was liquid. I was also thinking about the scale of his wings, which is a problem in the physical conception of any Dragon and the bulk of the body that somehow has to be lifted.

Nick Keller, Weta Workshop Designer

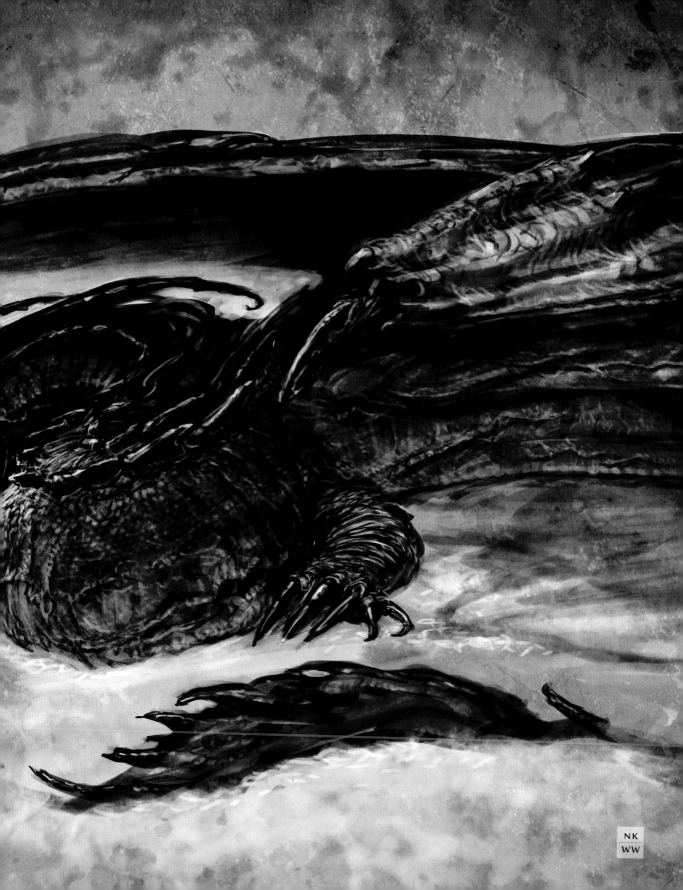

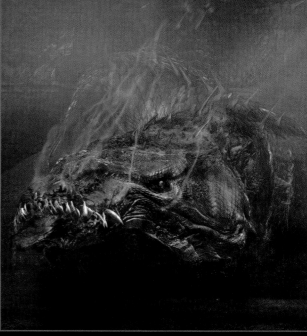

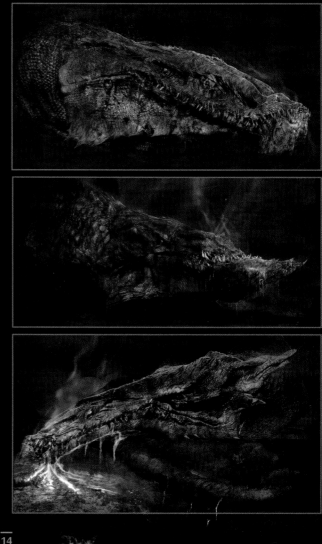

Peter had been talking about Smaug as an old, rotten creature, foul and decaying, so I painted saggy, wrinkled necks with filth and rot around his jaws. I tried to keep design elements from Tolkien's drawings in my concepts. Reading the book at a young age, the notion of the glow of Smaug had captivated me. Was it reflected light? Did Smaug literally exude heat and glow? Did part of his chest light up or was there fire smouldering while he slept? Playing to Peter's notion of him being old, I though perhaps he might drool in his sleep. Some of the chemicals that produce his flame would seep in a long, slow burn, bathing the chamber in dim red, with slabs of melted gold and treasure around him. In the book he was coated in gold and jewels from lying in them for so long, so I thought perhaps his heat had melted the gold and it had crusted on him.

In depictions of Dragons on their hoards, the gold is typically piled up and looks clean and shiny, but what would a hoard really look like with him lying in it all those years? What if his mere presence ruined it and instead of a thing of beauty it had slowly turned into a melted mass of gold slabs, with sloughed off scales or old skin and the remains of his meals and filth mixed in? I liked the idea that he couldn't help but destroy all these gorgeously crafted treasures. His nature was to ruin everything.

Greg Tozer, Weta Workshop Designer

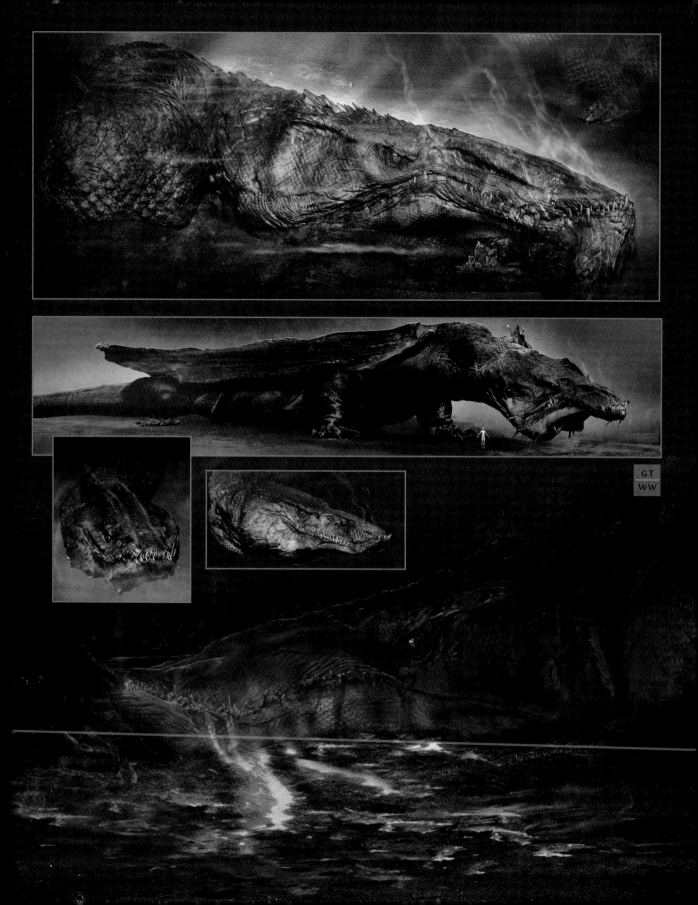

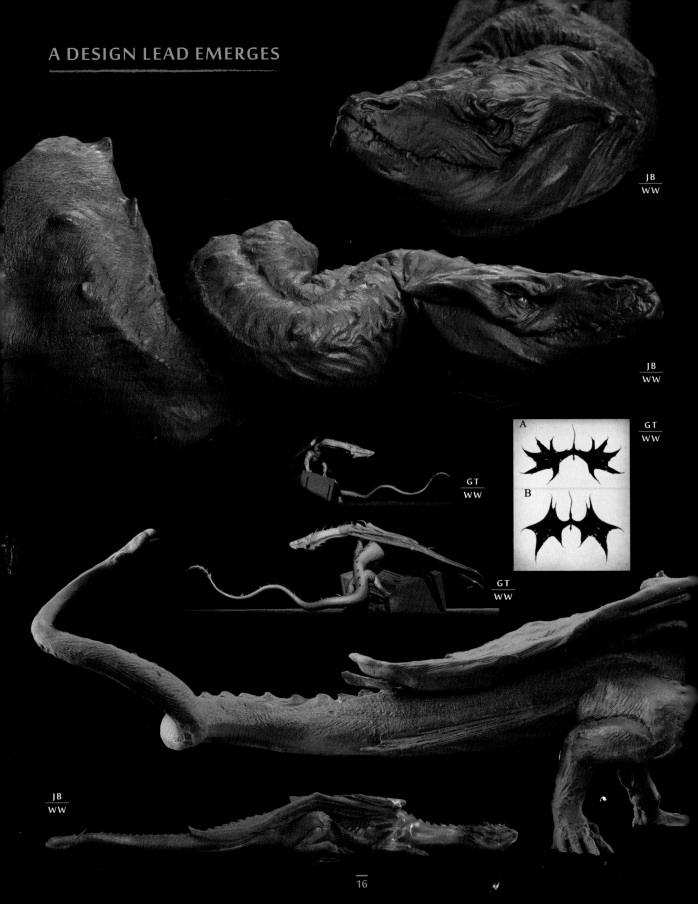

JB
––
WW

JB
––
WW

GT
––
WW

GT
––
WW

A

B

GT
––
WW

JB
––
WW

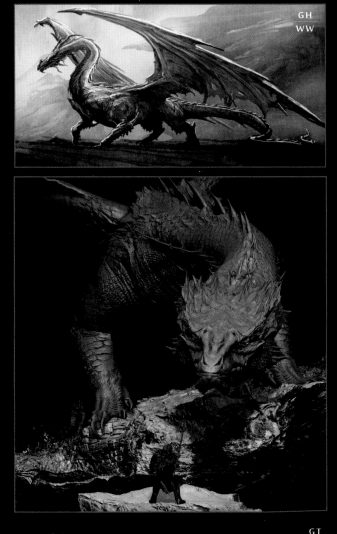

GH
WW

GT
WW

I was looking at Tolkien's own sketch of Smaug on his map of Wilderland and tried to emulate its serpentine qualities in my concept sculpt. I kept referring to that drawing: four legs and wings, long and wiggly with a forked tail.

The chest I gave him was similar to the ribcage on my pet bearded dragon, Rum. I liked the idea that it could flare out so that when he laid down it spread, but when he rose it would tighten and change in shape. It could be an interesting look when he inhaled, expanding before blowing flames. I highlighted the edges with a row of scales to help define it, giving him an area behind the chest into which his knees could tuck to keep him more streamlined when swimming or flying. The rows of scales also helped keep him from just becoming tubular, which would be boring. They created ridges and dips for gold to settle in or trickle through when he moved, and places where jewels could catch and become encrusted, as described by Tolkien.

I tried to simplify the head and not distract the eye with horns or fins. We still weren't sure which way Peter wanted to go and I found he often preferred designs that were quite focussed. I was trying to stay grounded in the anatomy and characteristics of real-world animals so Smaug would feel like a living thing and not get too fanciful. My concepts mixed crocodile and snake characteristics. We had talked about him swimming in his gold in a very serpentine way so I coiled his neck up like a boa *(facing page, middle)*, suggesting an undulating and twisting motion rather than just up and down, the idea being that he was resting amongst his gold, but there's also the feeling of being coiled and pulled back, ready to strike, so there's danger too.

Peter responded really well to aspects of these concepts and liked the head, which became a design lead that we followed.

Jamie Beswarick, Weta Workshop Designer & Sculptor

JB
WW

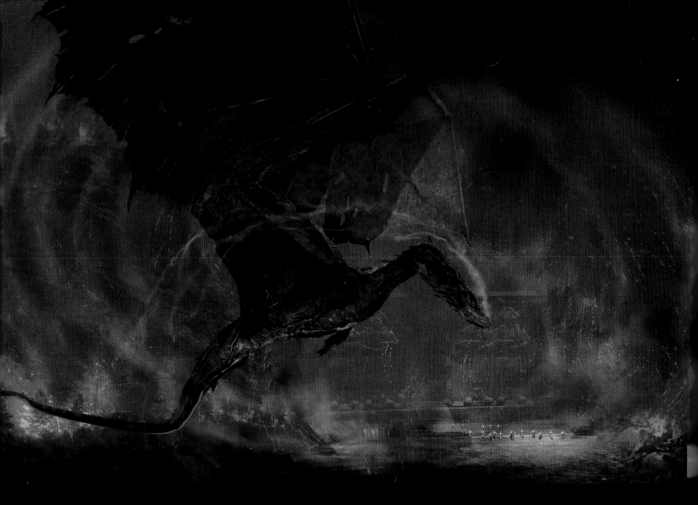

We had come a certain distance in our designs when the priority shifted. In the first film we would only catch glimpses of the Dragon, but Peter wanted him to be a slightly younger, spritelier Smaug than he would be in the second. He wanted to see a powerful chest as per Gus Hunter's illustration *(previous page, top right)*, and we began putting spines and spikes back on his head that Jamie Beswarick had come up with *(previous spread)*.

Peter didn't want Smaug's body to be as long as some of our earlier studies, but one of the main things he was keen to avoid was simple bat wings. We began looking at different wings that would cast interesting shadows on the ground, like giant clawed hands, reaching out over what he wanted to claim.

Greg Tozer, Weta Workshop Designer

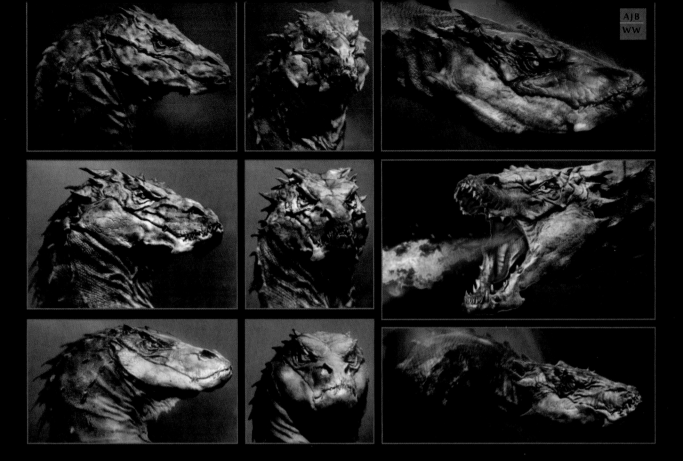

We had a general direction and elements that Peter liked in previous concepts, so I tried to fuse them all together and introduce some colour. Hearth stones become charred from exposure to fire so I thought it would be cool to see Smaug's mouth all blackened. He also had to be old, proud and commanding of attention; intelligent while still looking reptilian.

As we were getting closer I incorporated Peter's favourite elements from Jamie Beswarick's sculptures and the director's idea of rows of bladed scales that grew up into the Dragon's horns. That idea had sprung from the need for something which might move or flex in reflection of Smaug's mood and help him be as expressive as possible. They could be decorative, but they would also be functional and animate to convey emotion. When angered, Smaug's horns might flare up and look very spiky, but then relax back down, making him a very streamlined creature once when he was snaking through the gold.

Andrew Baker, Weta Workshop Designer

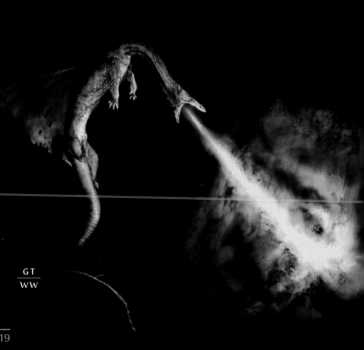

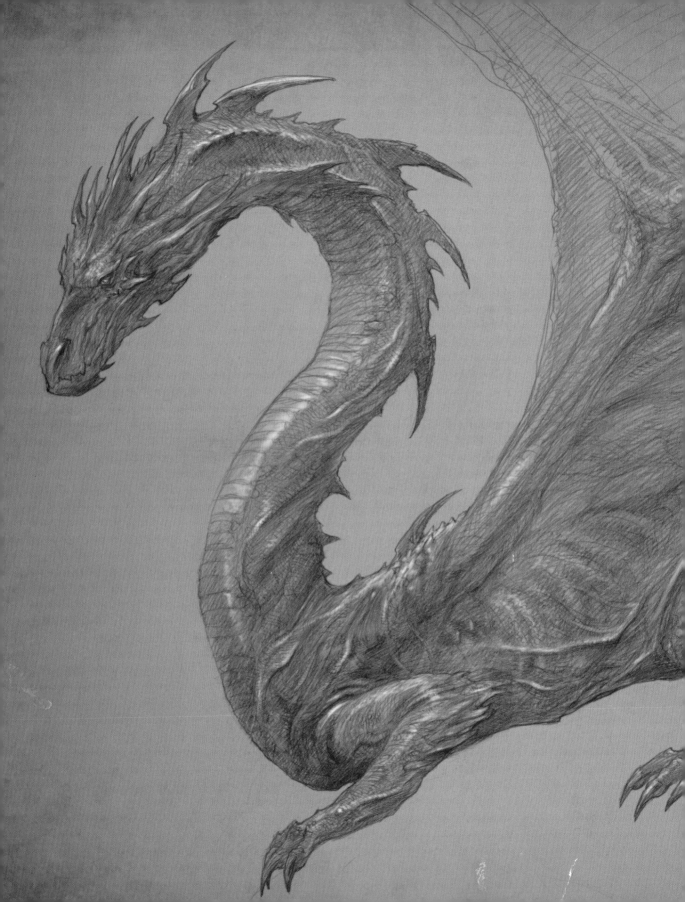

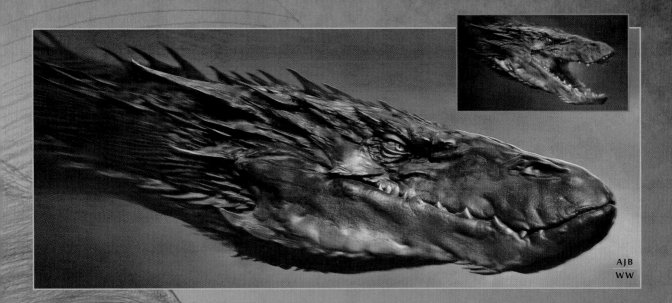

AJB
WW

Peter's strokes of brilliance are many, but I think one of the most brilliant ones was his choice not to revolutionize the classical Dragon. I think that was very brave and very smart. Peter had enough confidence not to feel the need to make Smaug his own by redesigning him to the point of being unlike anything anyone had seen before. Smaug is a traditional Dragon. He just happens to be a really amazing Dragon. *That* is the point of difference.

John Howe, Concept Art Director

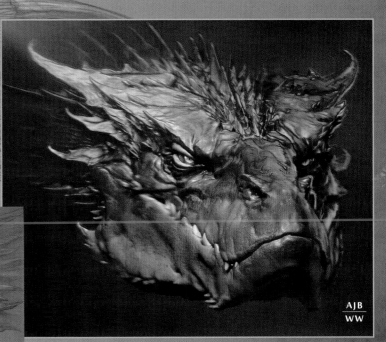

AJB
WW

JH
WD

JH
WD

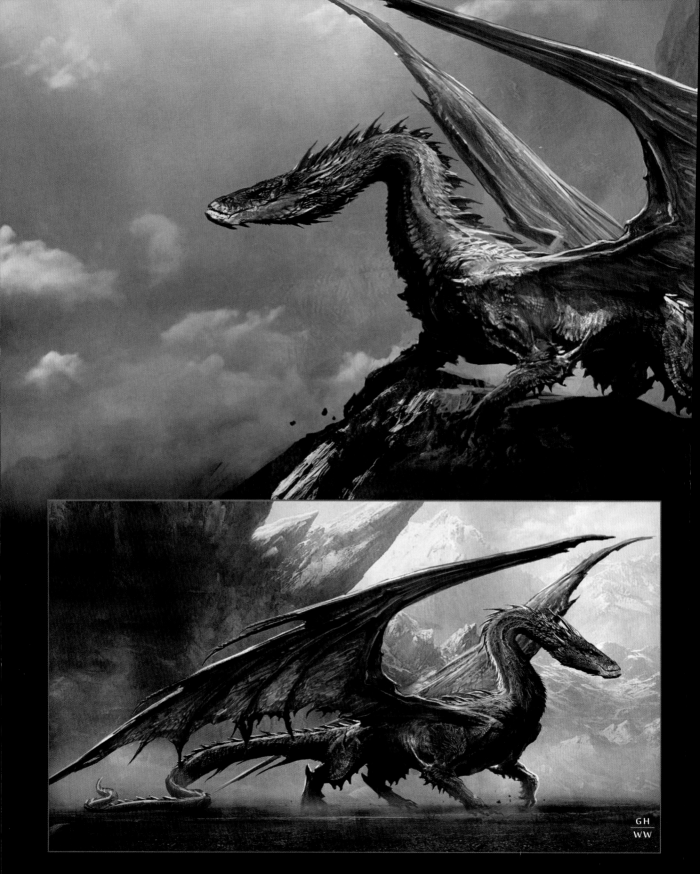

GH
WW

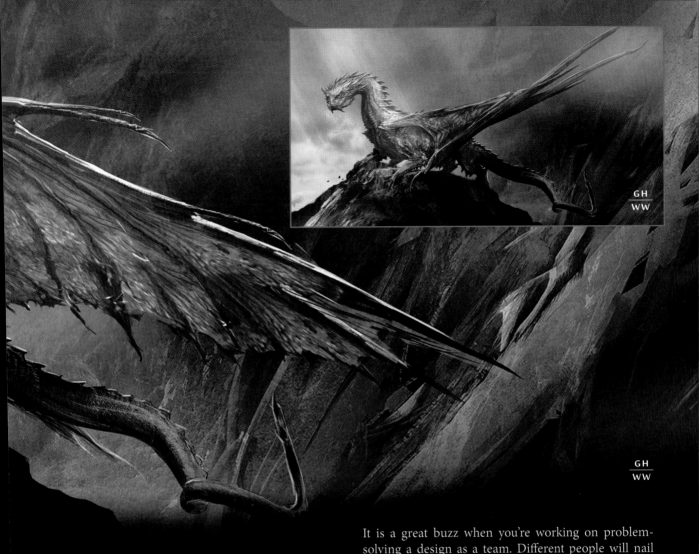

GH
WW

GH
WW

In one of my first concepts for the Dragon I had a go at defining the shape of Smaug's body *(page 17, top right)*. I tried to give his wings an aggressive shape, even when folded: very sharp and pointy. Everything about the design was sharp. Peter reacted quite well to it, but still felt it was a bit similar to what we'd seen before in other films, so I went back and tried to bring out more serpentine qualities *(facing page)*, slimmer and closer to Tolkien's iconic drawings. Andrew Baker and Jamie Beswarick had laid the groundwork for some very interesting shapes in their concepts. I brought in some of what they had done, including Jamie's ribcage design, with the legs that could tuck into the cavity behind it. Peter mentioned the idea of maybe having Smaug's scales flutter up and down through his body like a ripple effect, which I thought was a cool feature.

Gus Hunter, Weta Workshop Designer

It is a great buzz when you're working on problem-solving a design as a team. Different people will nail specific features in their various concepts. When something special appeared in someone's artwork everyone was quick to assimilate it into their own concepts to help reinforce the idea. Everyone had different strengths and unique things to offer: Gus Hunter, for example, does an amazing job of bringing ideas together in his illustrations and presenting them to Peter in a cinematic way. Often that was what it took to sell a design.

We were part of a bigger team too. Once we finished our work seeding ideas the guys at Weta Digital would take it to a whole new level. There is a limit to what we as conceptual designers can provide because we deal in broad concepts. So much problem solving happens once a design is animated and starts going into shots.

Paul Tobin, Weta Workshop Designer

I generated a very, very quick study for Smaug which trialled a different body to that which we had been using up to that point *(below)*. It was much more powerful, upright and less long and sinuous. Peter had really liked Gus Hunter's newest painting *(main image, previous spread)* so my maquette was a fast and loose attempt to mix some of the elements that he still liked from earlier designs with these new leads and a less ferret-like body type.

Jamie Beswarick, Weta Workshop Designer & Sculptor

JH
WD

JB
WW

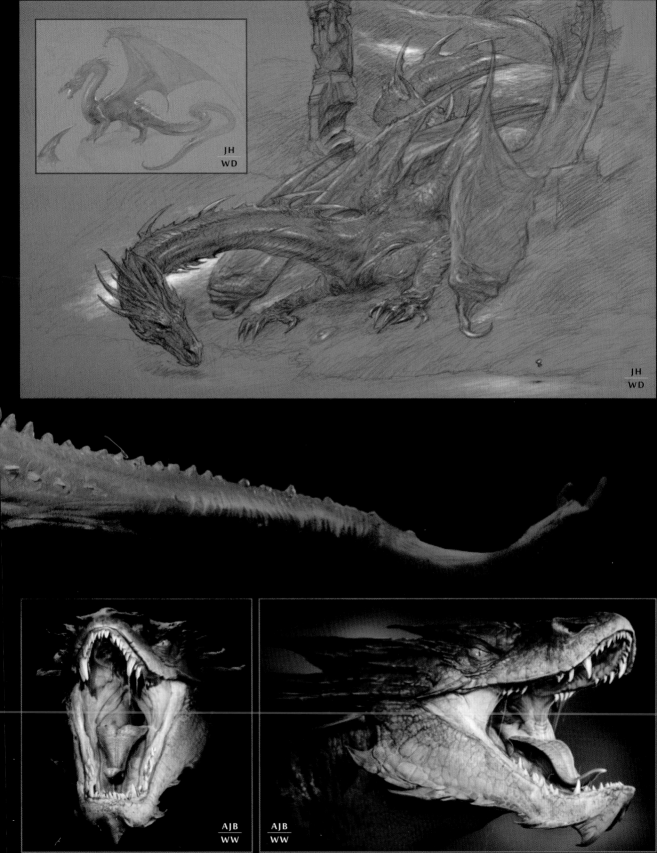

JH
WD

JH
WD

AJB
WW

AJB
WW

AJB
——
WW

I got to have one final pass on Smaug before we handed
him over to Weta Digital, putting in some finer details
and resolving the scale of his, erm, scales. Making him
feel sufficiently enormous was tricky but I thought
some variation in the size of his scales would help. I
made the skin on his neck feel very loose and wrinkly
like that of an old lizard and suggested that he might
also be shedding.

Andrew Baker, Weta Workshop Designer

The first shots for which we needed to have a working Dragon ready were those brief glimpses of Smaug in *An Unexpected Journey*. You could see bits of him, but the audience never really got a clear look at the whole design.

Even so, we still had to build the entire Dragon. Our first-generation Smaug began with Jamie Beswarick's maquette. He came to see us and we discussed the design concept. We scanned his maquette and took photographs as the basis for something that we could start testing and playing with to make sure it would work. The head was supplied to us as a ZBrush file from Andrew Baker. We then tried to find out which parts Peter liked and where we could improve or develop it to get the most out of the design.

Marco Revelant, Weta Digital Models Supervisor

"I MADE THE SKIN ON HIS NECK FEEL VERY LOOSE AND WRINKLY LIKE THAT OF AN OLD LIZARD AND SUGGESTED THAT HE MIGHT ALSO BE SHEDDING."

SIX LIMBS OR FOUR?

For Peter, it is never too late to have a good idea. The brief for Smaug came in hints and clues: he was huge, he was incredibly old and maleficent. Red-gold, as Tolkien described. Winged. Fire-breathing. Hundreds of designs were done and a design for the Dragon was completed, built and glimpsed in the first film.

You might think we were done, but Peter decided that he should have two legs instead of four. Back to our drawing boards we went, but most happily as it turns out. In the design that emerged Smaug was stronger in every way, with wing 'hands' that became much more expressive, and a more aerodynamic and powerful silhouette.

John Howe, Concept Art Director

JH
WD

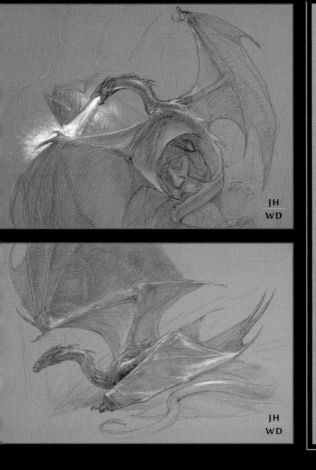

Weta Digital joined the design process for Smaug as the early designs were coming together and was responsible for the final character you seen on the screen. As part of the design and creation process they would ask things like, 'Do his joints articulate properly? Does the creature make anatomical sense, so that he can move and perform realistically on screen? Does the design have enough expressive range for the scenes Peter has in mind?' The answers to these questions fed back into the design process and literally changed the shape of the creature.

We have many teams that handle different aspects of the creation process; a unique blend of art and science. The essence of Smaug passed through many hands as he was modelled, textured, shaded, lit, composited and animated to become the character seen in the film. Ultimately, we want the audience to know that he is a fantasy but believe that he is real.

Joe Letteri,
Weta Digital Senior Digital Effects Supervisor

Peter never stops designing. Even after the first film had been released, he was thinking about how to make the best possible Dragon for the climax of the second. The model in the first film had been a fairly traditional dragon with four legs and wings on his back. We spent a lot of time figuring out how to make this arrangement work, but the problem was that Smaug was becoming quite wide. When standing he was starting to look too much like a bulldog.

At some point Peter asked about whether we should in fact be rethinking the anatomy entirely and consider exploring a creature that was much more snake-like, with only two legs. His forelimbs would be his wings, but also function as hands. It was performance that was driving this change. Before, the wings were really there just for the sake of propulsion, but now Peter was looking for ways to involve them in the acting and use them to help convey emotion. Our Models team began meeting with Animation to discuss how to make that work. How would a hand become a wing and also be able to walk?

Marco Revelant, Weta Digital Models Supervisor

It meant redesigning everything, but, just as with Gollum's changes between his brief appearance in *The Fellowship of the Ring* and his full reveal in *The Two Towers*, it was absolutely a change for the better, and which was barely noticeable because we had only fleeting, obscured glimpses of each character in the first films of their respective trilogies.

John Howe, Concept Art Director

We had done some movement tests in the days of Smaug having four legs and two wings. One of the things that wasn't satisfying was the fact that his front legs were so far from his head, separated by the vast length of his neck. They weren't substantial, and being so short and far from his head, they were lost to us as an acting tool. Getting rid of them and turning his wings into articulated hands was awesome, because his arms or wings were now long enough that his hands could reach his head. He could scratch with them or pick things up. He could pose with them and perform in ways the physiology of our earlier design precluded.

Eric Reynolds, Weta Digital Animation Supervisor

One thing we discovered when we went from four legs to two was that we didn't actually need as much body. We could reduce it, which helped the overall design.

We tested the new configuration in lots of poses: walking, flying, taking flight, to be sure it didn't feel out of proportion or unbalanced. We had been worried that the tail might be too long, but once it was moving that long tail looked really cool.

Marco Revelant, Weta Digital Models Supervisor

The long front limbs offered us so many great pose options. Smaug looked great with one claw around a pillar or standing at a bit of an angle, poised to launch himself forward.

Bats were useful reference for Smaug's movement on all fours. When vampire bats strut around on their wing tips it's easy to forget they even have wings because they fold away so neatly along the arms, something we chose to try and incorporate. The challenge was that even folded up Smaug's wings were truly enormous and the treasure room was filled with columns that he kept running into. We removed quite a few of them to give him more space to move around unhindered rather than compromise the strength of his performance.

Eric Reynolds, Weta Digital Animation Supervisor

Peter was quite clear that he wanted to see a kind of snake effect when Smaug was sliding in the gold or winding his way through the halls looking for his prey, so that demanded a long neck. We elongated it several times and with his new, keeled body he started looking really impressive, but how could we resolve those two back legs? Traditionally this kind of body shape tends to resemble a *Tyrannosaurus rex*, with chunky back legs, but that broke up the desired snake-like quality. We explored versions with different-sized back legs to try to find the right balance. John Howe was deeply involved in guiding how these changes would be implemented. He worked alongside us, drawing as we were modelling, and updating us with sketches of particular details as questions about them arose, refining the design as we went along.

Marco Revelant, Weta Digital Models Supervisor

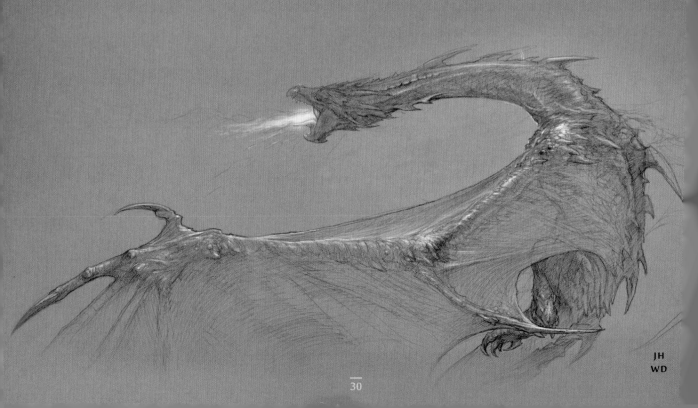

JH
WD

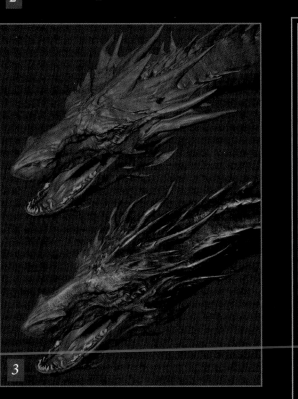

MODELS

◁◇▷

The Models Department creates every digital object that is rendered on screen or is used in the digital production. These may include complex characters or creatures, whole digital cities or simple props. Models are made by joining together multiple polygons (flat shapes made of straight lines) in a coarse mesh to give the shape of the object. That coarse mesh-like shape is then converted into a smooth surface. This is done during the rendering process by subdividing each polygon face into smaller and smaller faces until it looks smooth.

Models are produced in several ways, starting from maquettes, photos or artwork. If the model is based on a maquette, or we need to digitally recreate an object that already exists in reality, we will usually start with a 3D scan of that object. Once scanned, the digital data is imported and the modeller uses it as reference to build a model that works within the Weta Digital pipeline.

The Models Department also creates the hair and fur, or 'groom', as well as any digital costumes that may be required.

Marco Revelant, Weta Digital Models Supervisor

1. Untextured Digital Model.
2. Digital model of Smaug in early four-legged form.
3. Work-in-progress model of Smaug's head and digital paint over by John Howe suggesting design refinements.

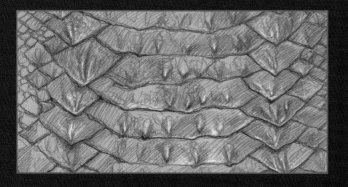

ANATOMY OF A DRAGON

One of the biggest thrills of working on Smaug was the very close working relationship we enjoyed with John Howe. Of anyone in the world, I think he has probably been chasing this Dragon for the longest time, so it was great that he had such an important role to play in guiding Smaug's development for these films.

Gino Acevedo,
Weta Digital Textures Supervisor/Creative Art Director

Smaug was so big and complex that we tended to focus on specific areas at different times. I would do sketches and hand them to the modellers. Most of my sketches were of little parts of him that warranted particular attention at a given time. I could give a drawing of a claw to Andreja Vuckovic, for example, an amazing digital modeller, who would come back in a few hours with exactly what I had drawn beautifully translated into 3D, every design intention suggested in the sketch interpreted with uncanny precision. It was such a pleasure working with the modellers, and the process always worked best when it was collaborative. Because of this complexity we came to understand the importance of holding regular meetings with every department involved. Each week we would convene in Gino Acevedo's office and look through what was being done. Everyone was able to pick out what was relevant to them and react, knowing what everyone else was doing at the same time was essential because each department's work directly affected everyone else's.

John Howe, Concept Art Director

It seemed like we had every department working at once on Smaug. One thing that surprised me was that we were able to do it all with just one digital model. In the beginning we thought we would need multiple models for different shots, such as one for close-ups and another for distance shots, but in fact the resolution of the digital model held up in all instances.

Marco Revelant, Weta Digital Models Supervisor

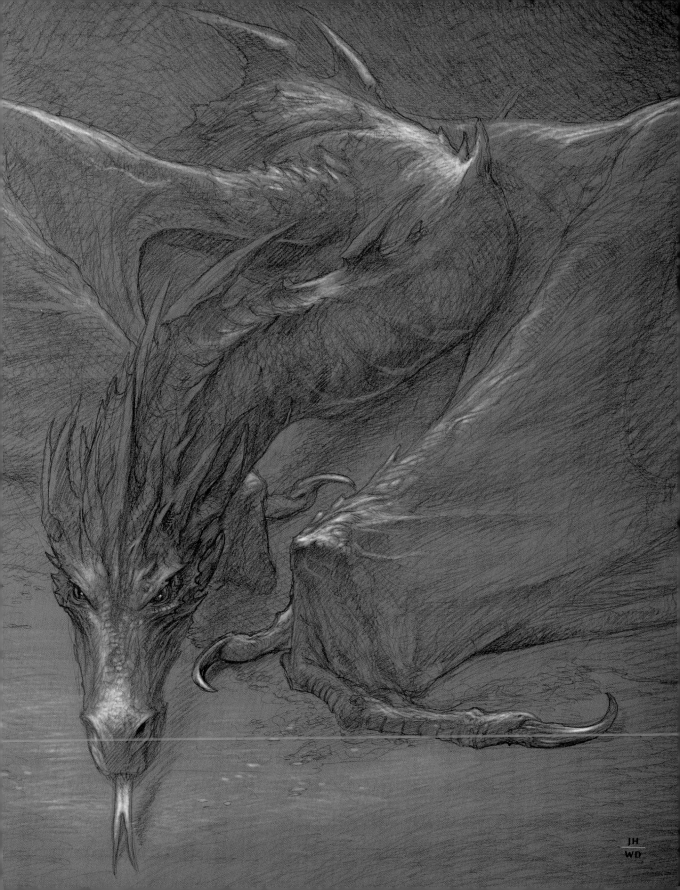

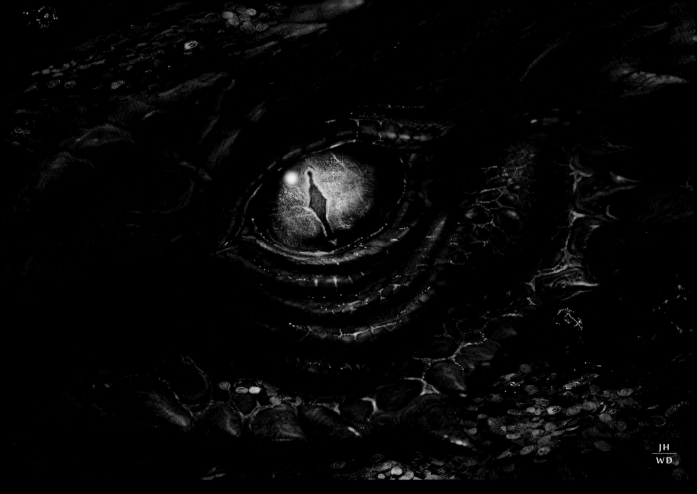

JH
WD

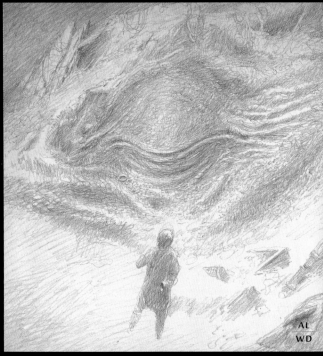

AL
WD

THE GLARE OF THE DRAGON

Smaug's eye evolved from one pencil sketch. The actual shape of the iris was a small doodle next to the main drawing. Often the best ideas are like that – incidental doodles in the margin of a drawing, rather than a prolonged exploring of dozens of incrementally differing options.

John Howe, Concept Art Director

Lots of people contributed ideas to the design of Smaug's eyes. Being the point of focus in his face, there was an incredible level of thought and detail put into the eyes themselves and surrounding scales. His slitted pupils weren't simple cat-slits, but had a more complex geometry to them and were dynamic, contracting and dilating. We wanted to get a range of colours into the eyes, so there were yellows, oranges and reds.

Gino Acevedo,
Weta Digital Textures Supervisor/Creative Art Director

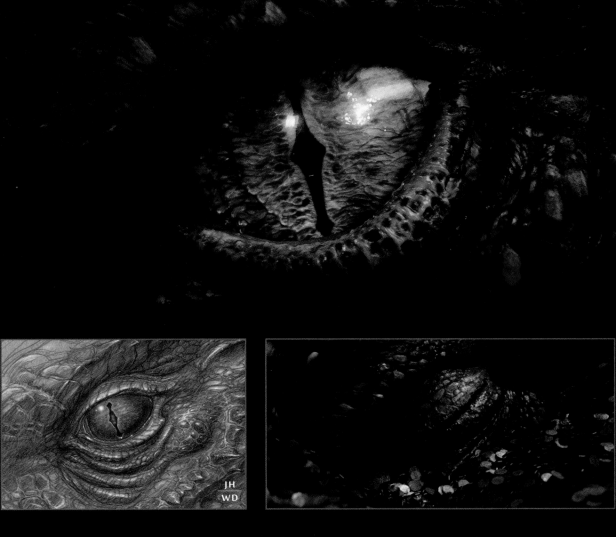

The eyes were very important because so much of a character's expression happens there. It was part way through our process that Fran Walsh said she thought the eyes were not as big and engaging as they should be. Having a small eye in relation to the size of the rest of the body is a good way to make something look very big. Big animals have small eyes compared to their size and small animals usually have large eyes, so it was everyone's natural tendency to keep Smaug's eyes small seeing as he is so huge, but Smaug also had to convey emotion. If his eyes were too small then it was harder to read that, especially at a distance.

Myriam Catrin, Weta Digital Senior Texture Artist

Everything is connected. When you start enlarging the eye you have to enlarge the eye socket. That comes at the expense of something else. Do you eat up part of the brow, or the cheekbone? Do you enlarge those too? Now you have changed the entire shape of the face. If you raise the brow ridge up then you have broken the silhouette of the head. There is also the relative distance from the eyes to the mouth to consider. There is a domino effect to every small change, plus, we were making these changes with animation rigging already in place.

But this is a decision that can only be made once you begin to see the creature acting in shots and realize, 'Okay, this isn't working. What can we change to fix it?' So we did and Smaug in the film has much larger eyes than he started with.

Marco Revelant, Weta Digital Models Supervisor

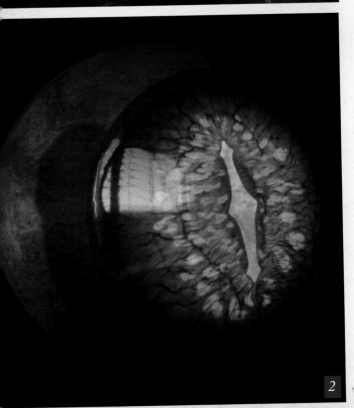

Often the artwork we present is intended to raise questions rather than answer them. In the book there's an iconic moment when Smaug's eye opens and a thin gleam of red pierces through the darkness, illuminating the gold and narrowly missing catching Bilbo as he stealthily climbs amongst the treasure. Of course we wanted to capture that in the film, but when creating a real creature, or as real as we can get it, an eye that illuminates from within and casts a glow is a tricky thing to pull off. I wanted to present some artwork to put that idea on the table for discussion.

Alan Lee, Concept Art Director

We experimented with eye glow, even going as far as shooting Bilbo with a searchlight-like effect. But, we realized that once we got beyond that moment in the story and began playing through the drama of the scenes in which Smaug performed, the effect wasn't going to work. Glowing eyes don't give a good sense of direction or intensity because they appear the same no matter how you look at them, so we went the other way and stripped that glow right out, as if they were normal. That gave us back the focus and intensity we needed so then we looked at how much of the glow we could dial back in without losing what we had regained.

Joe Letteri, Weta Digital Senior Visual Effects Supervisor

Smaug's eyes couldn't look like light bulbs, but the light bulb effect did have some nice advantages, such as seeing the back-lit veins through the cat-like nictitating membrane that slid across his eye when he blinked. But, how much glow would be too much, and how would we translate the artistic choice made into something that also made anatomical sense? We would see it both in close-up and far away, so we would prefer to use the same methodology to create the effect at all distances. That isn't always the case with creatures, but Smaug would be seen so much that we wanted to try and solve this in a way that worked for every shot so we didn't need to go in and use tricks every time.

Guillaume Francois, Weta Digital Senior Shader Writer

1. Early searchlight effect test of Smaug eye glow.
2. Eye glow test showing glow emanating from inside the eyeball.
3. Pupil and iris design concepts.
4. Close-up of eye membrane.

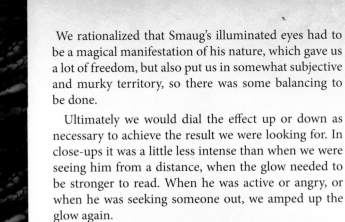

We rationalized that Smaug's illuminated eyes had to be a magical manifestation of his nature, which gave us a lot of freedom, but also put us in somewhat subjective and murky territory, so there was some balancing to be done.

Ultimately we would dial the effect up or down as necessary to achieve the result we were looking for. In close-ups it was a little less intense than when we were seeing him from a distance, when the glow needed to be stronger to read. When he was active or angry, or when he was seeking someone out, we amped up the glow again.

Jed Wojtowicz, Weta Digital Shaders Supervisor

The eye glow effect became something of a defining character trait and a tool we could use to convey his emotional state in a similar way to how we had utilized the dilation of Gollum's pupils to help signal a shift between his two personalities. They would dilate when he was Sméagol and contract again when the more sinister aspect of his character re-emerged. It was a very subtle visual cue which I am sure most people never consciously noticed, but which nonetheless succeeded in distinguishing the two characters inhabiting that creature. Smaug's irises would burn brighter when he was becoming tense or angry, like a furnace flaring.

Kevin Sherwood, Weta Digital Visual Effects Producer

Smaug's irises were also multi-layered. That was a big point of development in the final quarter of production when we started getting into his close-ups. He had layers in there to help achieve the 3D look of the crypts and semi-transparent membranes of the iris, and to provide a parallax effect when the eye moved in relation to the camera and light source, so shallower structures within the iris would throw shadows on deeper structures, especially in Erebor's dim lighting conditions.

Something else we discussed was animating certain elements inside the iris so that as the pupil contracted or dilated we would see things shifting in the eye, perhaps with a subtle delay on the top layer so that it moves out of sync with a lower layer in the iris and thereby create complexity and interest. These eyes were going to occupy a large portion of the screen after all.

Jed Wojtowicz, Weta Digital Shaders Supervisor

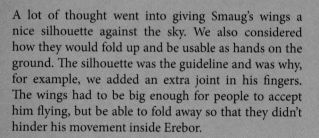

JH
WD

A lot of thought went into giving Smaug's wings a nice silhouette against the sky. We also considered how they would fold up and be usable as hands on the ground. The silhouette was the guideline and was why, for example, we added an extra joint in his fingers. The wings had to be big enough for people to accept him flying, but be able to fold away so that they didn't hinder his movement inside Erebor.

We also added an extra bone to help support the wing membrane at the elbow. No such bone exists in nature, but we needed it to support the shape we wanted. There were one or two anatomical liberties we took like this, but it was necessary to maintain tension in the wing.

Marco Revelant, Weta Digital Models Supervisor

We came up with the idea of giving Smaug a sixth finger so that he had a thumb and two forefingers free of his wing membranes that he could gesture and grab things with. These could be strong, articulate and expressive, while the remaining three fingers would be tremendously elongated and support his wings in much the same way a bat's do.

Joe Letteri, Weta Digital Senior Visual Effects Supervisor

Inset: Work in progress render. Note the absence of two detached manipulative fingers and thumb which would be present in the final design (facing page).

We examined bats in great detail, not just for what a bat's wing could do, but also to understand how we might need to design around their limitations, such as grafting on a primate-like thumb. Eagles' talons were also an important reference for his hands.

While we always looked for solutions in nature, an equally important design component came out of John Howe basically free-styling!

Marco Revelant, Weta Digital Models Supervisor

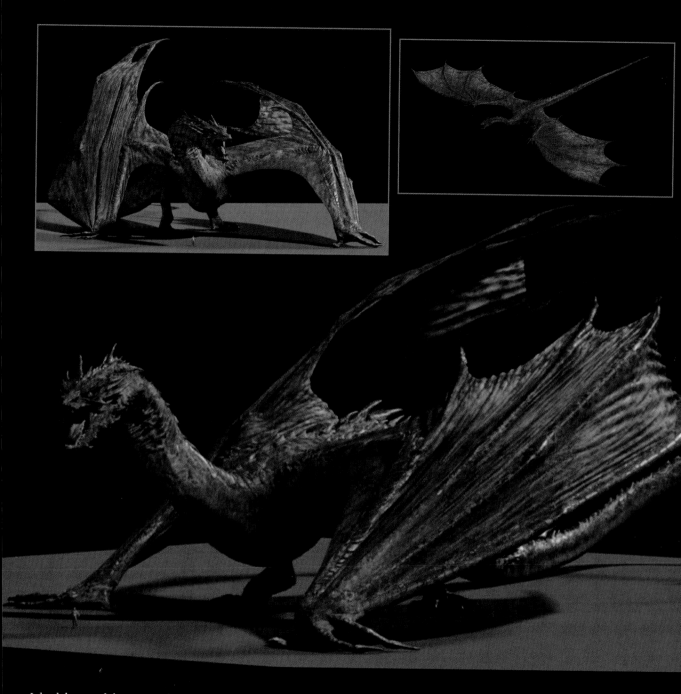

I had bat and harpy eagle skeletons on my desk for months. Smaug's anatomy blended elements from both. Birds derive their strength in flight from the muscles that anchor in their chests and they have a keel, which we loved. Bats have a flatter chest, rigid collarbones and more muscle mass on their backs. Smaug's anatomy fell somewhere in between.

John Howe, Concept Art Director

Peter talked about tattering the edges of the wings a little bit, with nicks and scars in the surface of the membrane. Our friends at Wellington Zoo had on ice a fruit bat that had died for us to look at. That was incredible reference for the wings.

Gino Acevedo,
Weta Digital Textures Supervisor/Creative Art Director

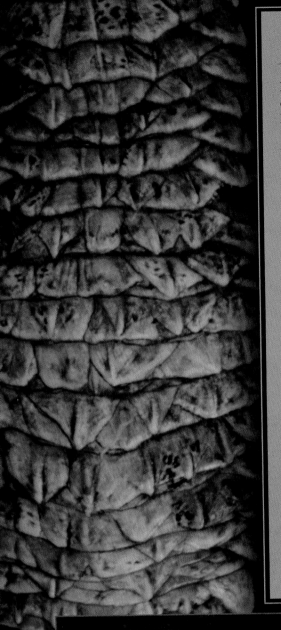

TEXTURES

In the Textures Department we determine and generate everything from skin pigment colouration to the kind of fine details like moles and freckles and other imperfections on the surface of a creature. We also work with displacement, which is when the skin surface is displaced by bumps, warts, moles and wrinkles, or, in Smaug's case, lots of scales. We add all that to a model.

Usually models come to us fairly smooth, because the more geometry is built into a model the heavier it gets, meaning it takes longer to load and work with because it is so complex. We say it is expensive to render if it takes a long time because there's a lot more information that has to be processed. It is conceivable that you could actually get into a situation where the creature is so heavy and takes so long that, when you take into account how many frames it has to appear in, you may simply not have enough seconds left in the days you have remaining to render it before the due date.

In Textures we can take some of that load off by creating much of that surface relief with our displacement rather than relying on modelled geometry. We always try to keep a model as light as possible so that it is easier to work with, but with Smaug there was such a difference in size in his scales, from tiny little pebbly ones to huge big plates and spikes that stick right out, that the bigger stuff had to be done in the model. Those big scales and spikes couldn't be achieved with displacement, and in terms of animation, they also had to be able to slide and move with the skin surface.

Gino Acevedo,
Weta Digital Textures Supervisor/Creative Art Director

SCALE BY SCALE

Smaug could fit a 747 jet airliner under each wing and was as long as two jets from nose to tail as well. Not only was he crazy big, but he had to be detailed down to the tiniest scale!

Eric Saindon, Weta Digital Visual Effects Supervisor

This creature was constructed one scale at a time. There were people who just painted scales for weeks and weeks. We debated the finer points (quite literally sometimes) of scales, of their shape, their size, how they moved and related to each other.

John Howe, Concept Art Director

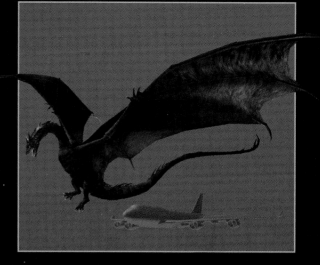

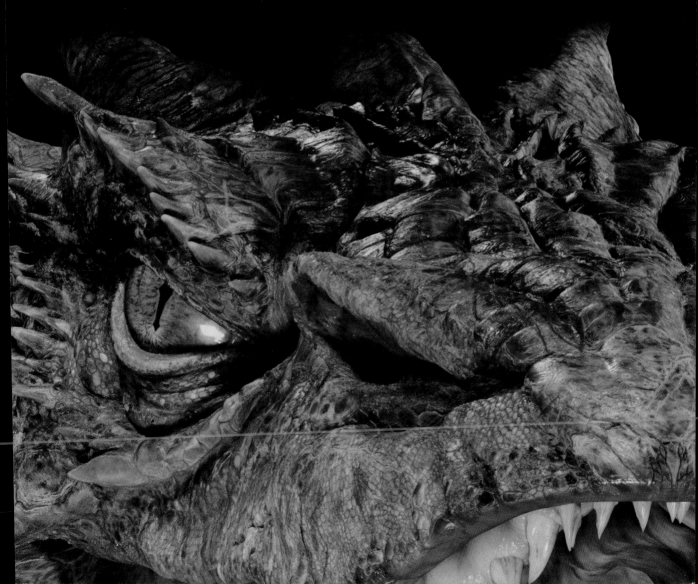

Myriam Catrin was our Dragon lady. She led our texture painting team on Smaug, but Myriam also draws the most amazing dragons outside of work and has a bit of a fascination with them, so she was born for this job!

Gino Acevedo,
Weta Digital Textures Supervisor/Creative Art Director

We numbered five in Team Smaug in Textures including Gino Acevedo, who supervised everything we did. Initially there was so much Dragon to texture that we each took responsibility for different parts: Alwyn Hunt took the tail, Robert Baldwin handled the wings, and in the beginning Victor Sanz Fernandez worked on the hands feet, legs and back, while I concentrated on the head and chest. Eventually we all ended up helping each other out. And of course, guiding the process with his drawings was our godfather, John Howe.

Myriam Catrin, Weta Digital Senior Texture Artist

"SOME WOULD BE BUFFED OR POLISHED WHILE OTHERS WERE NOT QUITE AS SHINY TO APPEAR OLDER."

Working alongside the Textures team were shader writers Guillaume Francois and Mathais Larserud. They essentially put together the recipe for the Dragon. They gathered all the information we created with our painted maps, all the colouration and all the displacement for the scales, and put them together so that they balanced nicely, adding just the right amount of specularity which accounts for things like the shininess around the eyes or on some of the scales. Some would be buffed or polished while others were not quite as shiny to appear older.

In terms of process, I would often take a screen grab of what they had achieved in a render and work back into it, painting in additional details to take it to the next level of realism. Then we would present this to the supervisors, Joe Letteri and Eric Saindon, for their input. Once we had their buy-in the concept would go in front of Peter for his sign off and then be fed back into the process to be actioned so we were constantly building on and improving what we were doing.

Gino Acevedo,
Weta Digital Textures Supervisor/Creative Art Director

1

1: Gino Acevedo would paint over the latest textured renders of particular parts of the Dragon (top), adding another level of detail and realism. Note the addition of a cuticle to the base of the nail in Gino's paint-over (middle) and the final textured model (bottom).
2: Close-up on the missing scale on Smaug's chest and John Howe's concept art (inset).

Gino Acevedo would go in and look at things like nails or teeth to see what extra realism he could add. We had the shape of a nail, but what else did it need? Real nails have extra layers of skin around their edges; they might be flaking or be worn. It was a very long process, but essential. We basically spent weeks going through the whole Dragon, inch by inch. With each spine on his back we would make a cut here, knock another slightly cock-eyed there, scratch scales and add scars, all in an effort to create the right kind of lived-in variance and natural asymmetry, giving him as much character as possible.

Eric Saindon, Weta Digital Visual Effects Supervisor

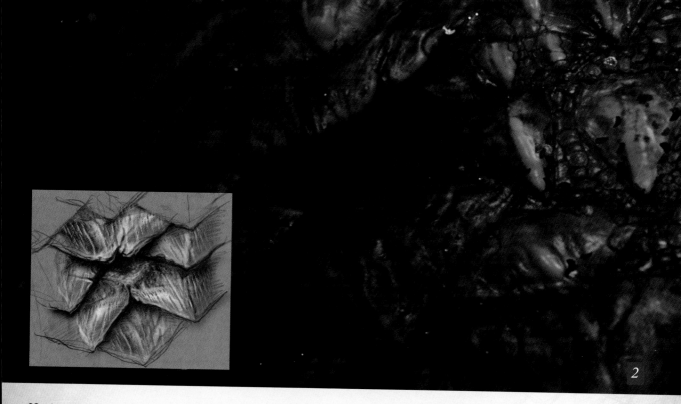

Having a range of sizes in Smaug's scales was very important because it meant that from a distance the eye could read a scaly texture at a broad level, the same way crocodiles have big plates on their backs, but as we got closer the detail didn't just get uniformly bigger. The closer we went the more scales could be made out, maintaining visual interest. Getting right in close, they would be almost microscopic.

Gino Acevedo,
Weta Digital Textures Supervisor/Creative Art Director

Detailing Smaug's scales required close collaboration between our modellers and the Textures team. The fact that we had already created a version for the first film gave us a very strong starting point. We knew from our experiences creating the close shot of Smaug's eye in the first film what we had to achieve and how far we had to take it.

With our first version of the Dragon, a lot was achieved using displacement, but we realized it couldn't stay in displacement. Figuring out what could be achieved in the model and what would be textured was an ongoing discussion. As the Textures team began painting scales on the model it became obvious that many of the scales were so big that they needed to be created as extracted displacement and topology to get enough deformation. They couldn't just be a texture, so there was lots of back and forth on this almost scale by scale, concerning that issue.

The smallest scales, which were often in places where we needed a lot of flexibility, were painted, but on his lips, for example, we wanted big scales. We allowed for movement by having the spaces between the scales more flexible, which was preferable to having the scales themselves flexing.

With all the detail being added the model was now becoming very heavy, meaning it takes a long time to load and do anything with. From a practical point of view, it meant that Animation couldn't animate in real time. We were doing everything we could to speed up the interaction, but we had never encountered this before with the other creatures like Gollum or the Goblin King. I think it was the first time we had to resort to using a low-resolution CG puppet for the purposes of blocking out the animation and then load the high resolution one just for fine tweaking.

Marco Revelant, Weta Digital Models Supervisor

Faced with something like a million scales to paint, it was less overwhelming for us to begin with just Smaug's right side. Once we had accomplished that we duplicated his skin, right for left, and then went back in and replaced all of the areas along the top and bottom, where the sides met, so that there was no unnatural symmetry. Scars, peeling and other unique features were added for more asymmetry, so even though we started with two identical sides, by the end they were totally different, just like any real animal.

The natural scale patterns on lizards and crocodiles were incredibly valuable reference for us. Randomness was very important, because nature does unexpected, irregular things. The more randomness we put into the configuration of Smaug's scales the more real he felt, but that is very difficult to design, so we were constantly looking at animal reference. I had thousands of pictures. I would select pieces that were interesting and arrange them on Smaug, using them as a kind of sketch to inform how we should arrange his scales to get a very natural feeling flow.

Andreja Vuckovic also went in and put hundreds of little gold coins and jewels in the cracks between his bigger scales where we imagined they had become caught and would cascade off him when he moved. Smaug was covered in tiny gems, something straight out of the books, but it was done very carefully because we didn't want him to look like a Christmas tree!

Myriam Catrin, Weta Digital Senior Texture Artist

"THE MORE RANDOMNESS WE PUT INTO THE CONFIGURATION OF SMAUG'S SCALES THE MORE REAL HE FELT."

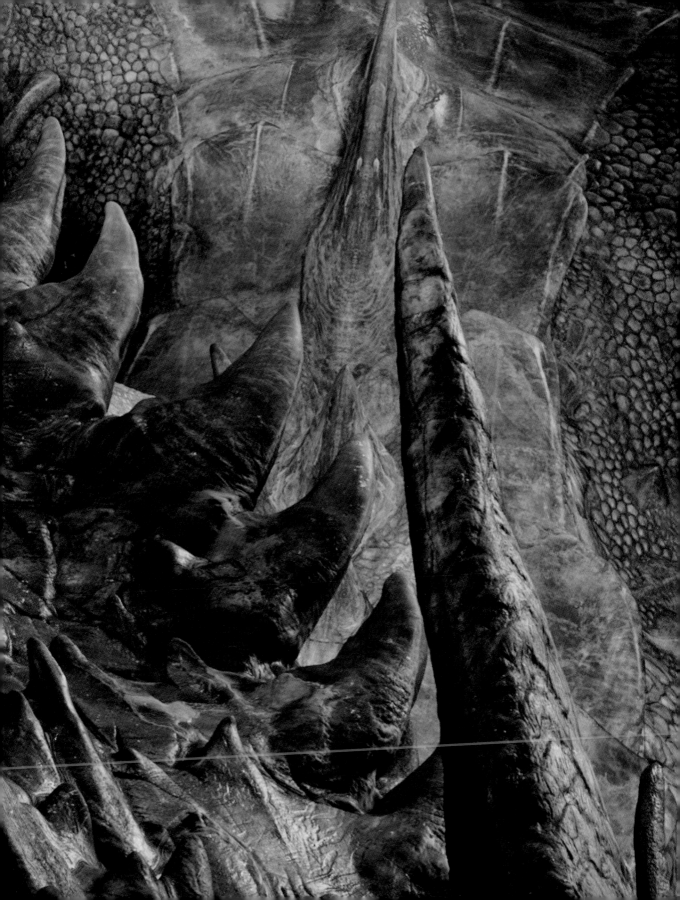

LIKE NO OTHER DRAGON

When designing something like Smaug, you are not designing a creature; you are designing a character who happens to be a Dragon. This is an important distinction, because when designing a character you are thinking in terms of personality, history and backstory. Peter's King Kong was a gorilla, but he wasn't just any gorilla, he was Kong, and you could pick him out of a line-up of gorillas in an instant.

John Howe, Concept Art Director

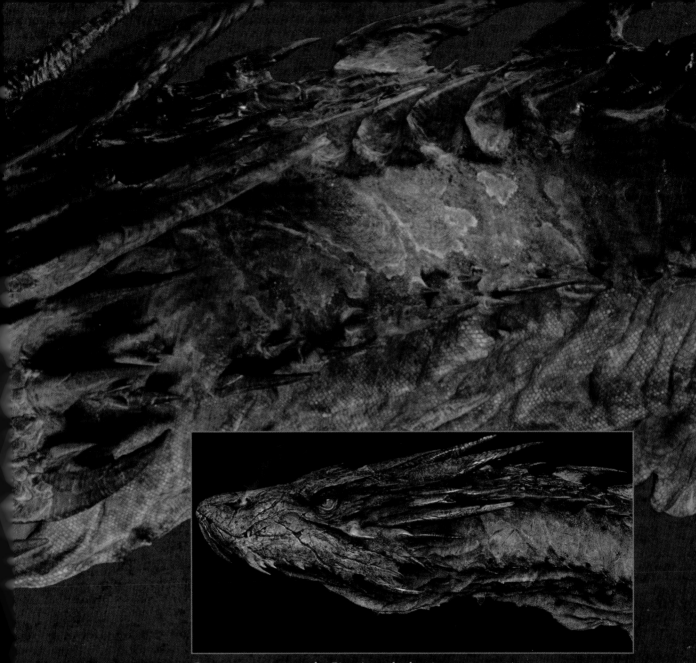

Concept art paint-over by Gino Acevedo showing scar suggestions.

Peter's brief was to make Smaug look ancient, with a missing scale on the front where you could see his teeth. We imagined he'd been in many battles with Dwarves and other races, as well as other Dragons. While he probably never lost, he had earned a few scars along the way, which helped him feel more threatening.

Another idea we explored was the notion of him having a slightly droopy eyelid, like you see on some older people. Smaug would be grand and truly awesome to look at, but also a bit worn around the edges and beaten up from all the years of battles and destruction.

Gino Acevedo,
Weta Digital Textures Supervisor/Creative Art Director

SCALES OF RED AND GOLD

We played with the wings having translucency, a bit like an inflated balloon. When the rubber stretches, it becomes more translucent, so when his wings were extended and the flesh was stretched they would be more translucent than when folded at rest. Too translucent and it could make the wings appear too thin, but in the right moments there was just enough of a suggestion of light coming through that the audience would accept it.

Guillaume Francois, Weta Digital Senior Shader Writer

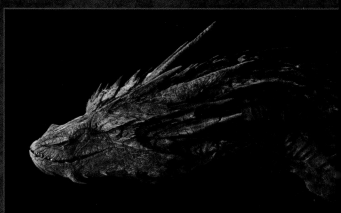

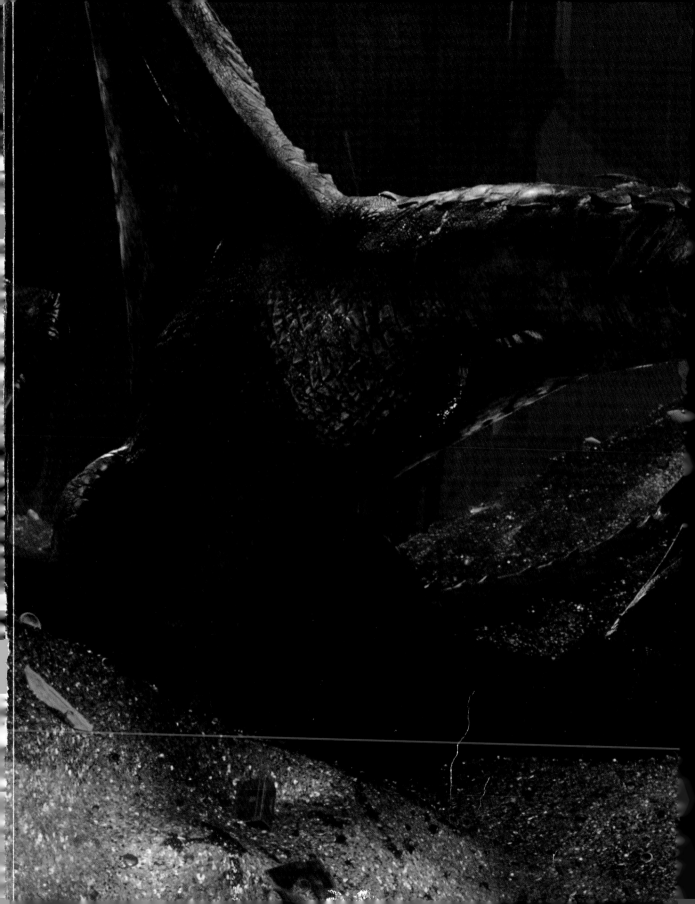

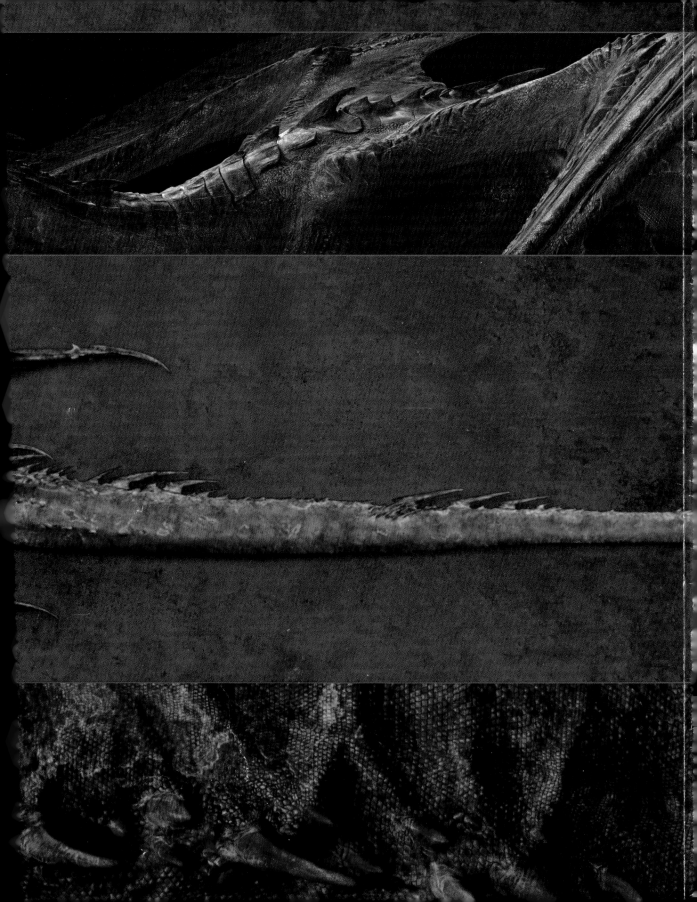

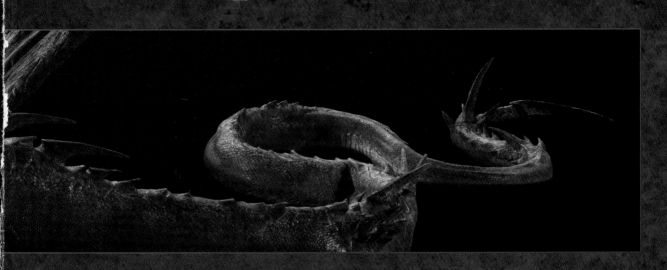

Originally Smaug was quite red all over. We desaturated him in places to make him feel a little older. Most animals are darker on the top and lighter underneath, especially flying creatures or those living in the sea, making them less visible to predators and prey. Smaug was described by Tolkien as a red-gold Dragon, but we didn't want to make his red too overwhelming, so it made sense to organize his colouring in a way that reflected what we see in nature, with a lighter red-gold colour underneath, as he is described in the book, but darker on the top. We coloured the thick plates on his back very dark, and by having a big shift in colour from top to bottom it read well from a distance.

To help him look aggressive I wanted Smaug to have a contrasting mask of black around his bright eyes, almost like a warrior's war-paint or the black you might see around a wolf's eyes. The eyes stood out and it made him even more expressive.

Because he would be in the dark so much, it was a good idea to introduce some pearlescence that would catch the light and help define his texture. In the dark of Erebor he would be almost black, so it was important to have qualities in his colouring that would read even in that dim light.

At the base of Smaug's wings Robert Baldwin painted darker bands coming in like a tiger's stripes which give him a very aggressive look and helped blend between the lighter colour of his wing membranes and the black of the bigger scales on his back.

Myriam Catrin, Weta Digital Senior Texture Artist

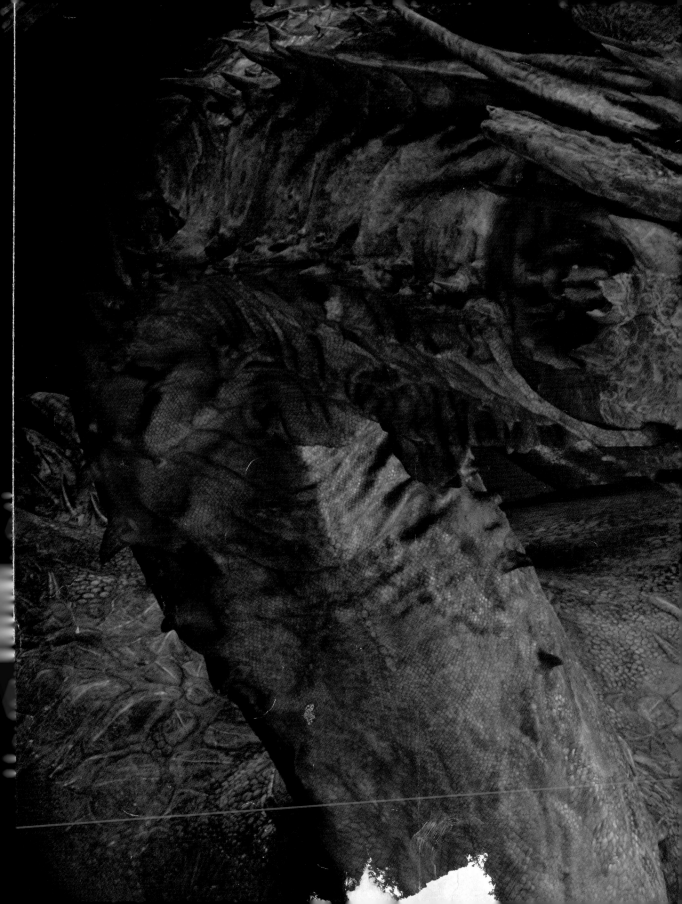

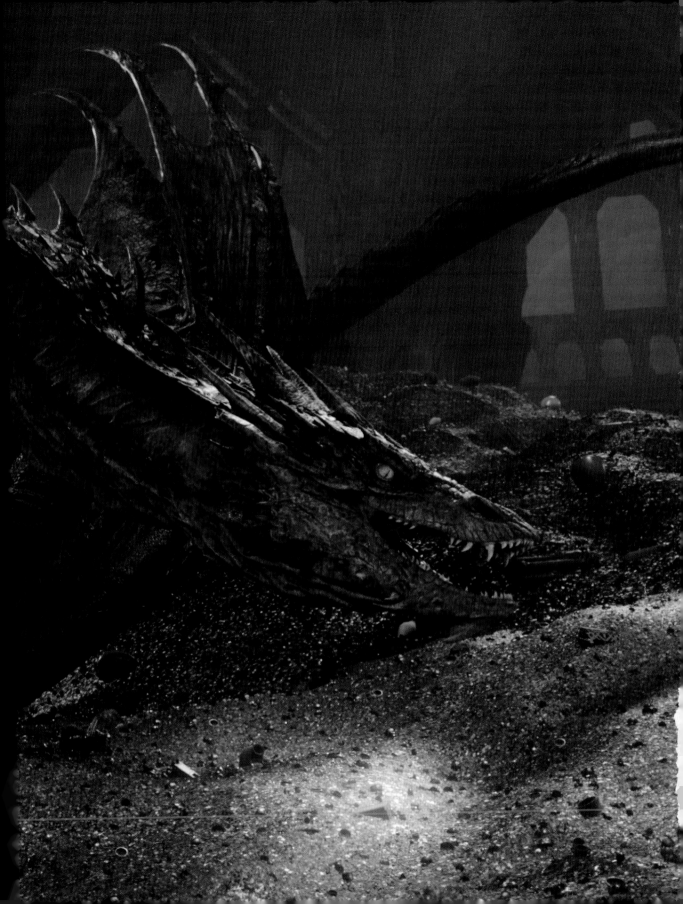

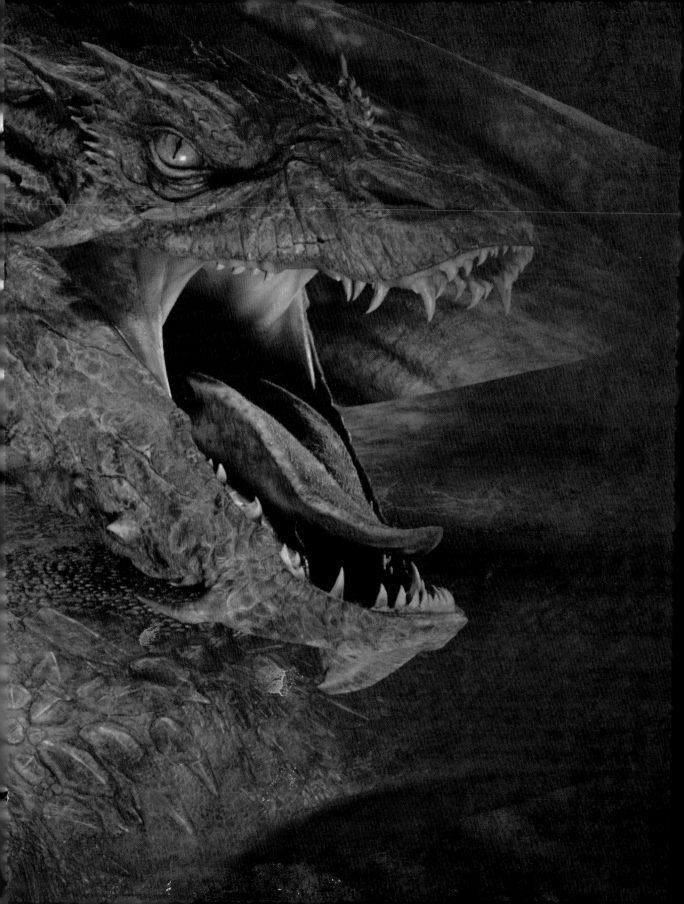

MY SCALES ARE ARMOUR

Smaug's surface treatments stemmed from ideas expressed in the concept design and the Textures team, but it also involved our Shaders team. When we work with shaders we're thinking about the interaction between the light in a scene and the creature itself so that on screen it appears to be completely real. It may involve the construction of different layers, which happens in discussion with the Textures department, and/or perhaps creating masks or special textures that can define different areas and features on the body so that they react differently with the light.

Smaug's scales ranged from very fine, permitting more flexibility and stretching on areas like his throat, to huge, thick, overlapping shields on his back. They were almost metallic, hard and shiny, with a varnished, iridescent quality. We identified all these areas and scale types on the Dragon as having certain properties which we then had to figure out how to achieve with code or equations.

Guillaume Francois, Weta Digital Senior Shader Writer

To help suggest age we had segments of skin that were being shed, with air pockets underneath the peeling surface. Just as the skin of a blister on someone's palm goes whitish and dry as it delaminates from the surface of the hand, and looks very different to the rest of a person's healthy skin, so Smaug has areas where his surface is in the process of moulting.

Jed Wojtowicz, Weta Digital Shaders Supervisor

My two words are motivation and registration. We put something in if it makes sense in terms of the reality of the creature. If there is dirt, then we ask, 'What colour is the dirt and where has the Dragon picked it up?'

Once there is motivation then there is the question of registration: we need to position the dirt and elements in the right place and ensure that in a particular shot we see the right amount and that it doesn't come across too strongly or not enough. Some concepts look beautiful when you are close in but as soon as you zoom out it might look like a camouflage pattern because it has all blended together.

Guillaume Francois, Weta Digital Senior Shader Writer

SHADERS

Shaders can be a difficult subject to describe to people who aren't necessarily familiar with the special effects industry, but essentially what we do in the Shaders department is define how things react to light. It's a broad topic that demands an understanding of what happens when light hits a surface and what happens to it before it then reflects and hits the eye, or camera, or rendered pixel. That also means understanding the nature of light itself, because to have a reflection you need light, so with the current rendering technology we use, we are responsible for programming the light as well as the materials.

The materials themselves tend to vary more than the light does. We do all sorts of things to the light such as make it bigger or smaller, colour it, barn door or columnate it, but essentially the light itself is still emanating the same way. The properties of materials are what vary the most in what we do. We're talking about the difference between red plastic and a red sock, or red skin, or some other material. With our tools and understanding we can imbue character or prompt an emotional response just based on how something looks and what material we have represented it as. We can take the same digital model of a creature with the same texture and make its surface read as any material we can think of. It all comes down to the way the light takes those values, propagates them throughout the surface and how they come out the other end and hit the eye, camera, CCD or pixel. That's what we program and control.

Jed Wojtowicz, Weta Digital Shaders Supervisor

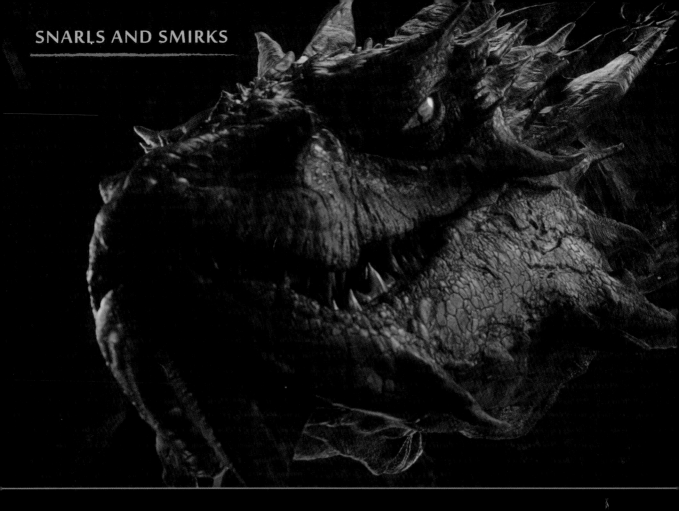

Superficially, Smaug's head was like a crocodile's, but in truth there was a lot more going on. Unlike a crocodile, his lips were mobile and able to pucker at the front or lift in the corners. He had to have the capability to express so we treated him no differently than any other digital character. But, while all that was true, there were some big differences as well. Providing such a full range of movement capabilities led to some issues when applied to such a huge face. We had to dial back how much his face moved, because if we scaled up basic human expressions to his size the tiniest of facial twitches suddenly became a huge slab of meat the size of a car moving several metres! We had to find a balance that permitted articulation without making him look rubbery by deforming or shifting his scales too much.

Marco Revelant, Weta Digital Models Supervisor

There were some key slider controls, like the nose wrinkler that gave us a snarl, or the jaw opening controls, which we spent a lot of time refining. You would think a jaw opening and closing would be the simplest of things, but in fact we had to consider and control very carefully how much his horns moved and scales deformed around his jaw when his mouth opened.

With the key controls resolved, we were able to get a good-looking facial performance and from there it was a case of adding the bonus controls that would give us nuances like pressing his lips together or dilating his nostrils. We had jaw controls and tongue controls as well, so the bottom jaw could hinge up and down, left or right, thrust forward and back. We could even run a membrane in the corner of his mouth, which gave Smaug a really cool looking swallow that you could follow down his gullet, using it to punctuate d...

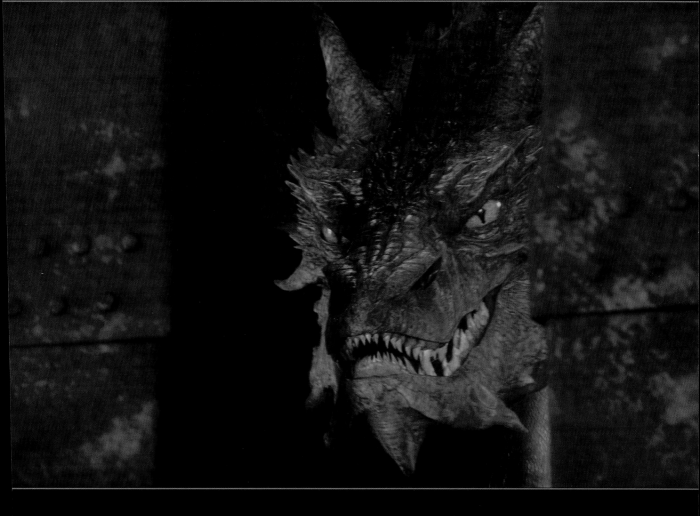

In terms of where on his long muzzle we animated his dialogue we chose shot by shot, so in a shot in which he was right up in the wide angle lens we restricted the articulation of his dialogue to the front of his mouth. In other shots we spread it across much more of the mouth and had his jaw move more.

Rather than being part of his skull we imagined Smaug's horns to be more like elaborate scales. We thought it would be cool if Smaug's horns flared or bristled when he was in a threatening mood or tucked back to change his profile when he was slinking around. They might flick around the way a cat's ears do. We were wary of overusing that because they still had to feel rigid, but carefully done there certainly helped underscore spatial variation in his performance.

David C̶̶ ̶̶ ̶̶ ̶̶ ̶̶ ̶̶ ̶̶ ̶̶ ̶̶ ̶̶ ̶̶ Supervisor

We used Smaug's tail quite a bit to help convey his state of mind, like a cat flicking its tail in agitation. People know what that means and it translated across very well. There were also shots in which he had it curled around him and it was slowly pulling through frame, and then others in which it was lashing about, destroying things.

Eric Reynolds, Weta Digital Animation Supervisor

Every creative choice we made as we wrestled with Smaug was decided by what would give us the best performance. The decisions were driven by his personality. We were looking for things that informed the audience about his character, his nature and his history. In the end everything that we do is in service to the storytelling.

Joe Letteri, Weta Digital Senior Visual Effects Supervisor

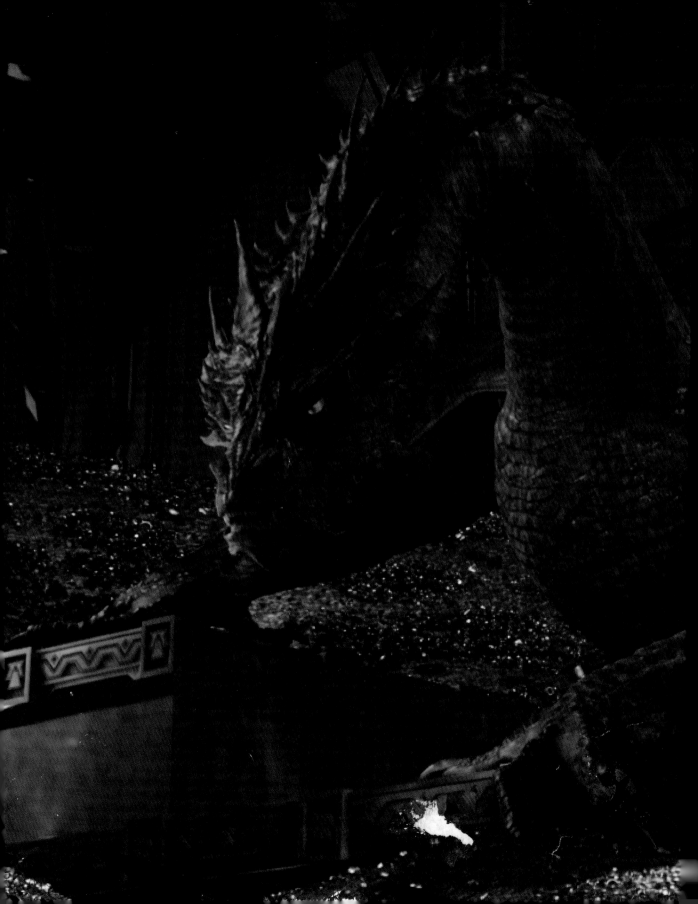

Above: Smaug's basic muscle and skeletal structure is revealed, the work of the Creatures Department.

CREATURES

The Creatures Department adds all of the anatomical features to the models of the creatures and characters, so they can be deformed (squished stretched and contracted while preserving their shape and volume) as they move. Initially, the Creatures Department provides the animators with a simplified puppet with basic controls. The animators don't have to see the muscles deforming, they can use an approximation of it and they have sliders that flex the muscles and change the shape of these simple pieces of geometry.

Once the animation has been approved, all of the information is combined in one file and processed by their muscle dynamics system, Weta's Academy Award-winning muscle system, Tissue. The Creatures Department maps the animation curves onto a high-fidelity skeleton, builds and attaches muscles to these highly-detailed bones, adds a fat layer and skin, and runs the in-house finite-element simulation. The animation curves move the bones, and that movement triggers the muscle simulation. The muscles drive the fascia (the fat layer) and the skin, and thus, the simulation system deforms the shapes. These 'bake files', as they are called, are then supplied to the Shots Department to be lit and rendered later in the shot creation process.

Simon Clutterbuck,
Weta Digital Digital Creature Supervisor

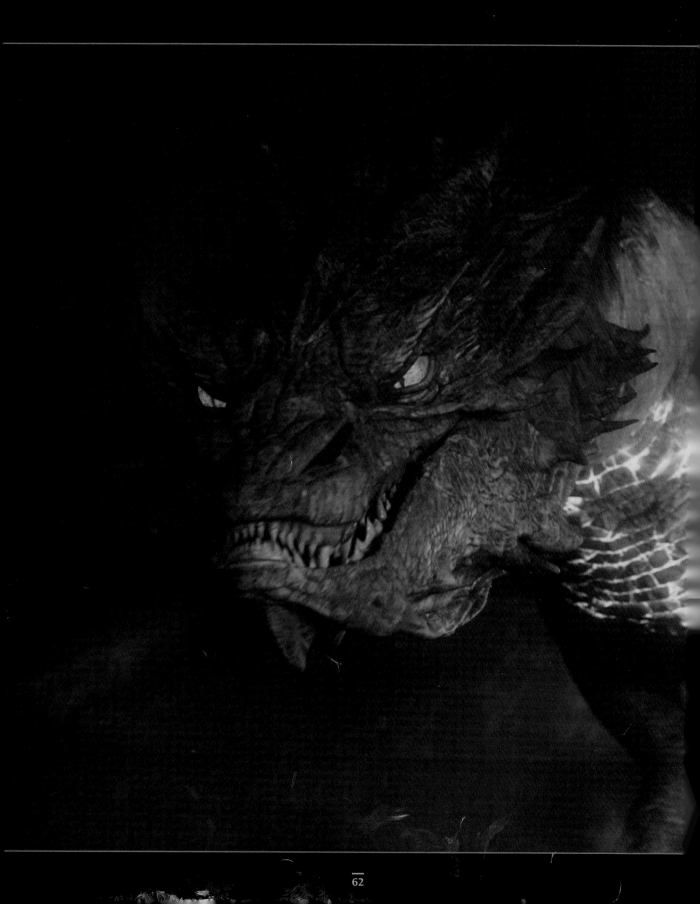

A VOICE LIKE THUNDER

It was critical that Smaug be able to convincingly perform dialogue, especially in close-ups. That wasn't necessarily going to be easy because of his reptilian physiology. Crocodiles, Komodo dragons and dinosaurs all lack the kind of lip articulation that would permit speech and aren't expressive animals, so we had to devise something akin to a human lip made out of scales that was still flexible enough for us to articulate.

One of the ideas that was kicked around early on was whether that issue could be circumvented entirely by having Smaug speak telepathically.

Joe Letteri, Weta Digital Senior Visual Effects Supervisor

The thought behind the idea of Smaug's telepathy centred on the notion that he would become connected with the hobbit because of his possession of the Ring. It built a connection between Smaug, the Ring and Sauron. In this way Bilbo, this tiny, invasive mouse of a creature in Smaug's domain, could have a dialogue with him and pique the Dragon's interest.

Benedict Cumberbatch, Smaug

The telepathy angle was novel, but we weren't ready to give up on the idea of Smaug communicating more conventionally. The very first test we did was a spoken dialogue test, because we firmly believed that we could make it work and that the result would be far more interesting to watch than some kind of disembodied mental speech. We felt he would be a much more compelling character if he was delivering dialogue that drove his expressions.

Joe Letteri, Weta Digital Senior Visual Effects Supervisor

Fortunately the quick tests we did with a basic animation puppet in early 2013 impressed Peter, Fran and Philippa enough that they agreed to go with full lip sync. We immediately rebuilt our facial animation rig from the ground up, creating a set of facial controls that would give us enough fine control over his lips, brows and various facial muscles to articulate expression the equal of a human face without making him look cartoony or over-animated.

We also had an amazing resource in the recorded deliveries of Benedict Cumberbatch, who had been cast in the roles of both of the films' biggest villains, the Necromancer, and, of course, Smaug.

David Clayton Weta Digital Animation Supervisor

Performance capture was a new experience for me. I must say it was strange at first, because we weren't just recording my dialogue when I flew down to New Zealand to play Smaug: it was a full body experience. I walked onto the mo-cap stage wearing what looked like a wetsuit with lots of silver things on it and my face covered in white guff. I felt rather silly, truth be told, but the whole process was so normal for the Capture team that their nonchalance quickly put me at ease. They have been doing this for years, going right back to Gollum on *The Lord of the Rings*. Once I was past that initial awkwardness the experience was actually quite mind-blowing.

Of course, I'm not a fire-breathing wyrm with a long viper-like neck, tail and wings, and I can't fly, so there were things about the performance that I couldn't do. Even on my belly, straining my neck up and projecting my chin to do the kind of things serpents do, constricted my voice, so there was a certain amount of compromise that we had to accept regarding the physical performance, but at the same time it was freeing. I have never felt more free to play. I had been worried that the experience could be like filming against green screen in which you are acting to a vacuum, but I think, when playing something that is so far from yourself, being in a little suit and running around a carpeted square room is actually the best way to do it. There's no continuity, there's no make-up, there's no costume, you are free; and if we needed to go back over a line we could do it again, right then, and simply splice it in. There was a sequence that covered five or six pages of script, and once we had it I asked if we could do it again from the beginning. I ended up doing it three times, back to back, with a little break in the middle, which was great because when you shoot big films like *The Hobbit*, with huge crews and complex effects and set-ups it isn't usually logistically possible to run through such long sections uninterrupted. We played the scene in its luxurious entirety, like a piece of theatre. Even though it was the most technical form of filmmaking I have been involved in, paradoxically,the system that the team there have devised has evolved to the point at which I as a performer was completely free of the filmmaking technicalities that usually stagger the process and make it laborious.

Benedict Cumberbatch, Smaug

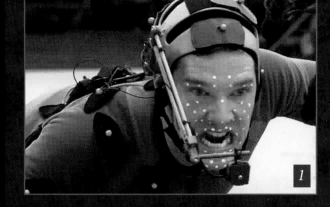

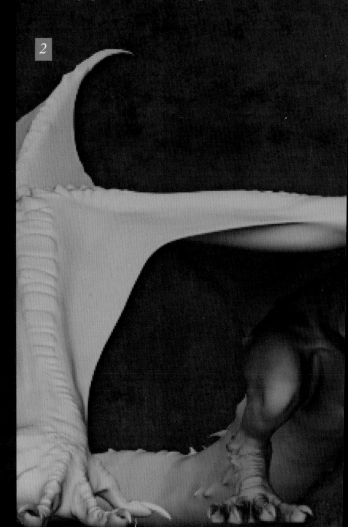

1: Benedict Cumberbatch in his performance capture suit on the motion capture stage.
2: Smaug's posed, untextured digital model.

now here I was on set repeating them, painfully aware
of how amazing his deliveries had been!

ADR

ADR – Automated Dialogue Replacement, is the process of re-recording dialogue for any given character after the filming process. This is usually to improve sound quality, change original lines recorded on set, improve diction or alter the performance. In most cases this is done in a recording studio, with the actor standing in front of one or two microphones. The Smaug ADR recording sessions required a much more extensive setup in order not to compromise either Benedict's performance or the quality of the recording. When Benedict recorded ADR for Smaug, he performed it with his body as much as his voice - literally down on all fours, slithering his way around and rising up to full standing height throughout scenes. This is an issue for a studio recording setup because, when an actor moves so much as an inch or two away from a microphone while speaking, the sound is uneven and not useable. To get around this we rigged a mocap helmet with two microphones pointing down at his mouth, so that wherever his head moved, there were two microphones moving with it. The other factor we had to consider was Smaug's massive dynamic range within a section of dialogue, as Benedict went from a whisper to a shout, it was extremely difficult to capture such varying levels at a consistent quality, and with two microphones being so close to his face some of the lines felt unrealistic, almost 'too close'. To help with this, an additional three placement microphones were required in front of Benedict to act as safety coverage for the helmet mics, to properly capture the vastly important characteristic of Benedict's wonderfully dynamic whole-body Dragon performance.

Morgan Samuel, Assistant Dialogue Editor

For the performance capture work I was on stage with Peter, working directly with him. During my ADR I was in a room with Peter, Fran and Philippa. Smaug continued to adapt and evolve through that process. I've never worked with a team that was so dedicated to the perfection of their creation, but at the same time so completely willing to throw out their most precious ideas to embrace new and better ones. The four of us had a fantastic time. The focus of the ADR sessions was obviously the voice, so it afforded us a chance to fine tune and experiment with some variation and character. We did a lot of takes and produced a lot of choices for certain moments.

Working with David Farmer and the Sound team was delightful. They facilitated things so that I could move about while we recorded. I had a microphone in front of me and leads coming off a pack on my back so that I could roam around on this platform in the room. It elevated me physically, which created a sense of authority that reinforced the character. In an effort to

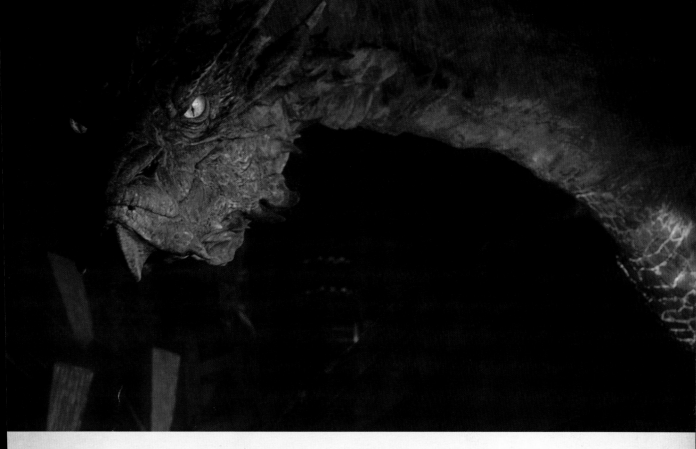

recreate the sensual quality of Smaug's lair, the platform was also padded and they put a lovely, comfortable rug underneath it, so it felt as if I was truly some giant Dragon luxuriating on his pile of gold. Those coins would be like the beads in a bean bag to Smaug, sliding around his form and trickling off him like liquid as he coiled between the pillars.

Benedict Cumberbatch, Smaug

There were several aspects that made up Smaug's sonic presence: speech, beast vocals, claws, wings, and fire, but speech was the most important, and it began with Benedict Cumberbatch's amazing vocal performance. One of the things we did during recording sessions was allow Benedict to hear his voice beefed-up and reverbed in his headphones. Often actors will alter their performance to try to simulate a monster-sized beast, which can come across sounding inauthentic. Allowing Benedict, Peter, Fran and Philippa to hear a

preliminary process permitted the actor to concentrate on the character and perform in his own natural tonal register without trying to create the 'processing'. Hearing his voice in a large cavern-sized reverb also helped him pick his pacing, letting the echo taper out between lines or words. All of this combined to subtly add to the character Benedict was in the process of creating while recording.

The final processing of Smaug's voice was similar to what Benedict heard, but was much more involved, including audio processing plug-ins that were too CPU-intensive to run in real-time while actually recording his voice without a distracting delay. We ran several processes, including pitching his voice down, beefing up the low end, creating a stereo image to add width, and also adding reverbs to create the Erebor space. Most were very subtle, but at a high resolution and combined they had a significant, realistic, effect.

David Farmer, Sound Designer

We had some tough choices to make early in the development of Smaug's voice. When a character speaks, clarity is typically of the utmost importance. You don't want the audience to have difficulty understanding a character, as that can take them out of the movie experience. Any time a voice gets treated the way I was processing Smaug, there is the risk of losing clarity. I kept comparing the process I was doing to the original reads to make sure I wasn't altering it too far, but I had another problem – believability. For this voice to work, I felt very strongly that believability was an even stronger factor than clarity. The last thing I wanted was for the scene to just sound like two men talking. It had to be a hobbit talking to a Dragon.

There was one very important process applied, though often subtly. The beast side of Smaug was primarily alligator growls that I had spent about seven days recording, but I found there was an almost jarring difference between the speaking voice and the alligators. The two didn't seem to connect enough and so it sounded like two completely different things. The final layer in the speaking voice was to overlay, usually vocoding, alligator sounds to play underneath Benedict's spoken lines. This layer was usually so subtle that the listener would be completely unaware of its presence, but if it was taken away, a very compelling characteristic would disappear. This also provided the glue that bridged the speaking voice with the alligator growls that took place between his dialogue lines.

At the end of Benedict's recording day, I got a few minutes to make requests of him that were other sounds, not scripted or dialogue based, so I asked him to give me some serpentine hisses, breaths, growls, lip smacks, *hmmphs* and *harumphs*, etc. These wound up being a goldmine of pieces used to fill in other gaps between his dialogue. I created a library of sounds, vocoding these with alligator growls, that I could place wherever I needed while maintaining the true character that Benedict brought. It all seemed to work. In one of the later reels Peter asked me to add in a bit more of the underlying alligator to a line and said, 'I'm hearing that line as Benedict, not Smaug.' That's when I knew that Smaug's voice had crossed the line into being its own character and not simply a processed human.

David Farmer, Sound Designer

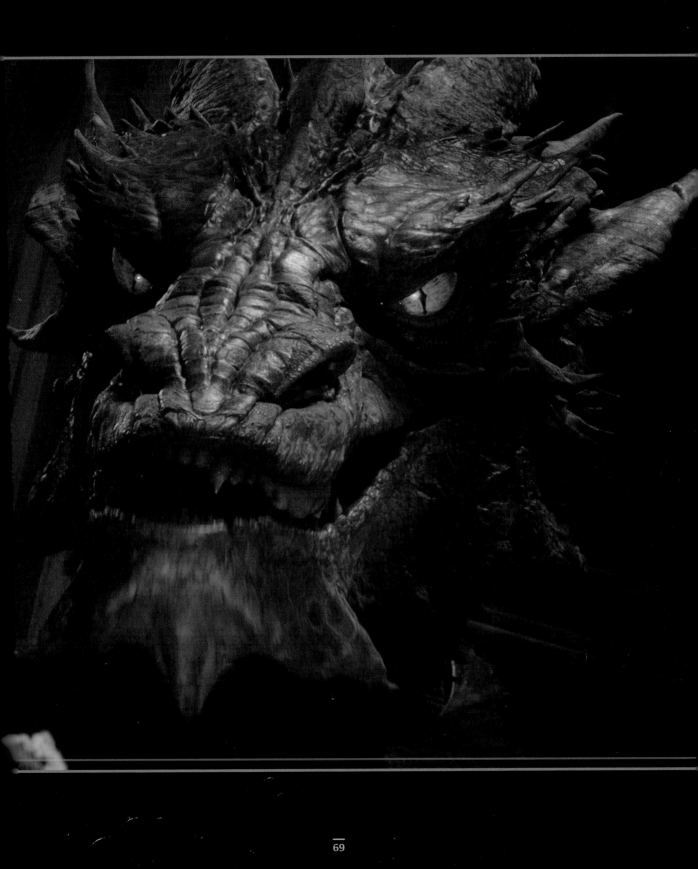

Pride is Smaug's foremost characteristic and his greatest flaw. He boasts about what he is capable of, of his power, both physical and psychological. He knows that the mere rumour of him strikes terror into the hearts of men. He knows that he is capable of causing destruction with the merest flick of his tail, the slice of his talons, or his breath of fire. He announces it when he says, 'I am Death'.

Initially when Bilbo, this seemingly innocuous entity, appears in his presence, he is something for Smaug to toy with. He would never admit it, but I think there's an element of loneliness and curiosity in the Dragon, otherwise he'd have simply destroyed the hobbit, but Smaug wants a game. He wants stimulation and he wants to be entertained, and like a cat with a mouse, he riddles Bilbo. It isn't the same way Bilbo and Gollum riddle, but there is parity in the sense that he wants to use his mind rather than just his brawn to defeat, or at least investigate, this new character in his midst.

With Smaug's pride comes an idea of invincibility, and it cloaks his one insecurity, the patch where his scaled armour is incomplete. He was maimed by an arrow from Dale. It didn't kill him, but Smaug knows he is not the invincible engineer of destruction that he is mythologized to be.

The result is a wonderful David and Goliath struggle between the Dragon and Bilbo. It is what is beautiful about *The Hobbit* – the journey of an everyman of meek and humble beginnings, who just wanted a quiet, settled life, thrown into positions of abject terror and peril and coming out triumphant. Even this incredible force of evil does not deter Bilbo. Smaug toys with him, trying to pick out who he is before destroying him. There's a real cruelty at work, a predatory monster toying with his catch, and Bilbo is terrified, but, importantly, it doesn't paralyze the hobbit.

Benedict Cumberbatch, Smaug

The design of the shots in the treasure hall provided us with a nice variety of actions to animate. We had Smaug prowling cat-like, advancing on Bilbo, flashes of anger and destruction like knocking over a column or lashing his whip-like tail, so there was plenty of scope for us to experiment with his movement and weight. The lovely thing too was that it was a slow build through the scene he played opposite Bilbo, gradually revealing more of his sadistic nature.

David Clayton Weta Digital Animation Supervisor

Smaug is so physically different from me that much of what people witness in his final performance is the work of the incredible team at Weta Digital. My face isn't that of a dragon, so the performance that I offered was something which was translated, augmented and adjusted onto the scaly head of an air-liner-sized beast. It was the inspiration that initiated the process of animation. And now, having been through this process, I know I can take pride in seeing the most important elements of my characterization translated by those amazing artists onto a very inhuman form. Everyone knows I played Smaug, but the truth is that thousands of people have spent thousands of hours creating this marvel of cinema. He is removed from how I walk about in life and while I love being a character actor, there's nothing that I could do that could touch the magic of what Weta Digital has brought to him on top of what I gave them as ideas. It was a beautiful collaboration.

Benedict Cumberbatch, Smaug

Our animators incorporated as much of Benedict's performance and as many of his nuances and subtle character choices as we could. Initially we transposed the performance capture data of his expressions onto our digital model of Gollum because that was close enough to human that we could assess the facial performance free of the distractions of Smaug's unique appearance and just ask ourselves, 'What's the personality here? What of Benedict's performance is coming through on the digital character?' We wanted to ensure it was working before importing that performance onto our digital Smaug puppet.

Then the question became, 'Where does the focus need to be placed?' That was especially pertinent with regards to lip articulation because the Dragon's mouth was so large and long, being stretched around a huge muzzle rather than a flat face. We found that much of it needed to reside on the front, but obviously we couldn't restrict all of his dialogue to just that one small area. We wanted his jaw to articulate as well, but carefully controlled the amount that it opened and closed, compared to the size of the lip shapes he was making as he spoke, especially when we were dealing with him and Bilbo together in close-ups. It became a case of working through each line of his performance, refining the range until we had something that looked comfortable but was also expressive.

Joe Letteri, Weta Digital Senior Visual Effects Supervisor

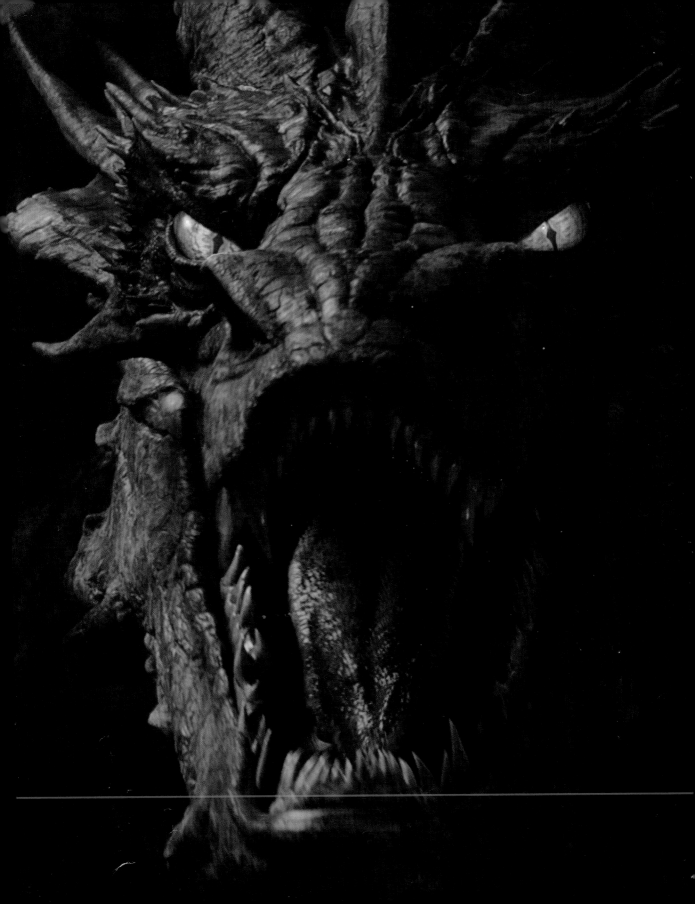

ANIMATION

The Animation Department, as the name suggests, is responsible for making everything move, including pushing around digital props and cameras or the complex art of bringing computer-generated characters to life with believable and relatable performances. Our animators work together to create character and creature performances with nuances and realism. In the workflow of traditional hand-drawn animation, the senior or key artist would draw the 'key frames' and an assistant would do the necessary 'in-betweens'. In computer animation an animator creates the important frames of a sequence, and the software fills in the 'in-betweens'.

Where an actor's performance has been motion captured, the animators use the edited motion capture data as a starting point for their animation, establishing the baseline motion faster so more time can be spent exploring and finessing the finer nuances of the performance. Creatures and stunts that can't be motion-captured are entirely key-frame animated, using reference material from nature to make them as believable as possible.

David Clayton, Weta Digital Animation Supervisor

Smaug had quite an emotive range. Even being a big reptile, the design never constrained his ability to act, so that was very good. He could be condescending, sarcastic and arrogant, which was great fun to animate, but he could also turn it on and be full of rage and fury.

Peter asked us to get some paranoia going in Smaug – lots of quick eye darts and suspicion. That was unexpected, but it made sense and added a depth to the character beyond just being a big greedy, angry Dragon.

David Clayton Weta Digital Animation Supervisor

Smaug might seem like the most powerful creature in Middle-earth with no reason to be worried about anything, but he was actually written as quite paranoid: about the Dwarves lurking outside, planning to steal his treasure out from under him. And the thought of those people down in Lake-town conspiring against him, helping the Dwarves: 'How *dare* they?'

There might be something quite seductive about the indisputable majesty and power of Smaug in the beginning when he was lounging in his bed of gold. I think even Bilbo was probably somewhat seduced by the insanely magnificent creature. He was so superior to the hobbit and obviously enjoyed the little game of cat and mouse that he played with him, but the moment he felt he had lost control of the situation, such as when Bilbo pulled his trick with the Ring or the Dwarves invaded, then Smaug's anxieties came to the fore and he became truly terrifying. The game was over. Now he was protecting what was his with jealous

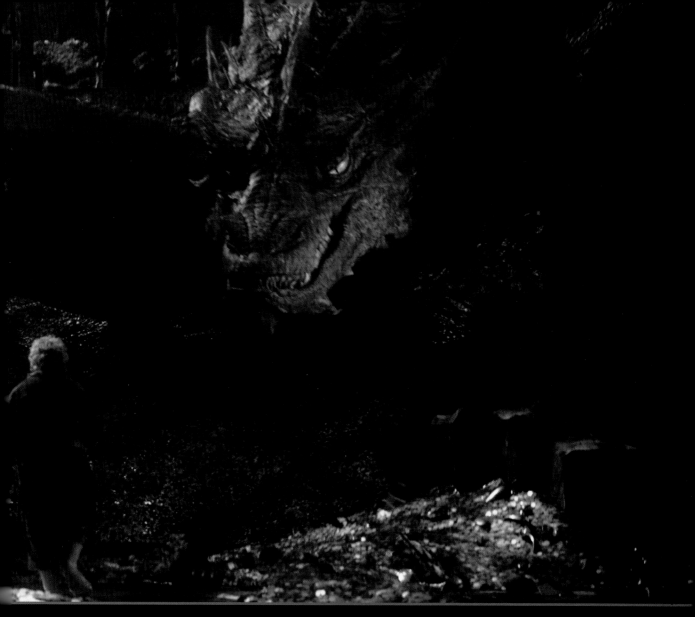

rage, which made him much scarier. It wasn't a sane personality they were dealing with, but an irrational one. Smaug was psychotic, and if you have ever been around someone like that you will know that seeing them unravel is terrifying.

Kevin Sherwood, Weta Digital Visual Effects Producer

Anyone walking by and overhearing us as we were animating Smaug would probably have laughed. Working on this guy, my process involved making all kinds of funny sounds as I was trying to find the energy and beats of each shot. I have my own Smaug impersonation and I think everybody who worked on him did!

Michael Cozens, Weta Digital Animation Supervisor

Smaug's neck was very mobile and we did lots of acting with it, and if his head made a quick movement we could create ripples down the neck or have the saggy flesh beneath his throat jiggle around, paying the price for that quick motion to help him feel huge and old. At times it was also challenging because if the head was doing one thing and the body another at a slightly different angle, we had to use the neck to link the two with a nice, strong shape. I had a piece of paper on my desk featuring a picture of a duck with a straight neck and a big strike through it, because that was a shape we never, ever wanted. We strived to keep that head flowing naturally off the neck with nice-looking curves in it. No ducks!

Eric Reynolds, Weta Digital Animation Supervisor

A DRAGON'S HOARD

Peter Jackson envisioned a huge cavernous tomb-like space for Erebor. In total the environment spans over one and a half million square metres. Smaug was laid out on a sea of gold coins, which we had to make sure were the right scale for both Smaug and Bilbo, so we couldn't cheat them. One of the very, very smart guys in charge of coin simulations worked out that the volume of all the gold in the treasure chamber, even after subtracting the empty space between coins, was

the equivalent of 480 quadrillion New Zealand dollars. That was Smaug's net worth, which had to put him at the top of the Middle-earth rich list.

There was so much gold to be simulated. We were solving something like 18 million individual rigid body coins just to cover Smaug. It was very technically challenging, especially in stereo vision, but artistically there were challenges too because once all those coins started rolling over and flipping around it was

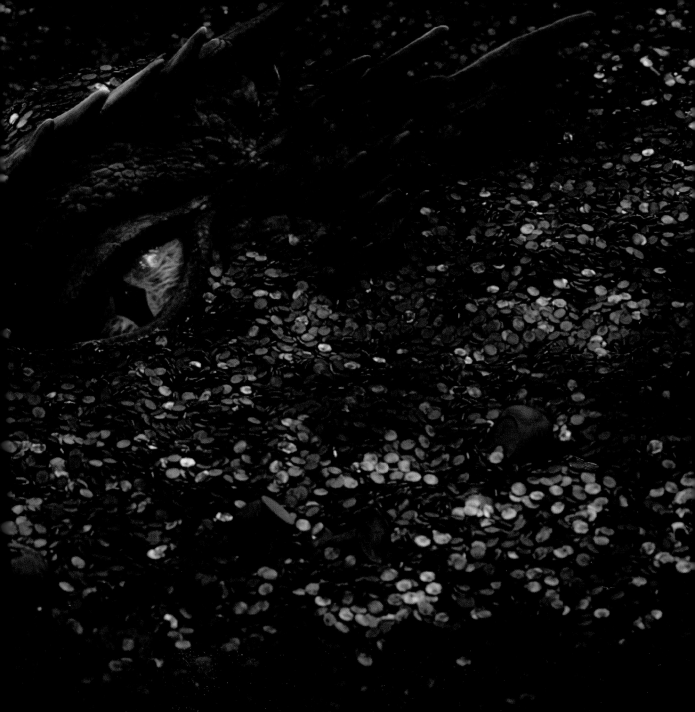

like watching a lightshow with little flashes of light everywhere. It had been our original intent to have the gold very shiny, but we found it worked so much better when we dulled it down and made it appear soiled and sooty. The coins still had highlights and some shine, but it looked better and wasn't distracting from the lighting of the characters.

Eric Saindon, Weta Digital Visual Effects Supervisor

We calculated that the sheer volume of gold visible in one of the shots was equivalent to the total United States national debt!

Kevin Sherwood, Weta Digital Visual Effects Producer

LIGHTING

Weta Digital's Shots Department creates the digital lighting and handles the rendering of CG assets, defining the overall feel of the shot. Lighting artists – also known as lighting TDs or technical directors – take the CG props, creatures and environments and light them in much the same way a Director of Photography would on set. That process involves the creation and placement of digital lights and lighting effects to sculpt and shape the lighting in a way that meets the director's vision and assists in telling the story of the film. Lighting subtly guides the audience where to look and what to focus on within the shot.

Eric Saindon, Weta Digital Visual Effects Supervisor

LIT BY GOLD AND FLAME

When assigned a shot to light I start by looking for what the focus of the shot should be and then try to use light to bring out the character. We use light to lead the eye where we want people to be concentrating their attention in the shot. Smaug was very enjoyable to light because we had so much artistic freedom. We could put lights wherever we wanted because generally we weren't having to match or extend live action footage shot on a set or outdoors where we have things like the sun to consider. We could place lights wherever we thought it benefitted the shot aesthetically without ever seeing the source, making every shot a beauty shot.

Miae Kang,
Weta Digital Lead Lighting Technical Director

The treasure chamber *(overleaf)* was lit to be very film noir. It was dark and cavernous and Smaug himself was only revealed gradually as he moved in and out of pools of light. We almost never saw all of him at once. The lighting in those shots aligned with Smaug's nature in the scene, which was somewhat playful and not yet the crazed engine of destruction that he became once enraged.

Eric Saindon, Weta Digital Visual Effects Supervisor

Strictly speaking, given the scene took place deep inside a mountain of solid rock, the treasure room of Erebor should have been pitch black, but that would have been a very boring scene! Just like any movie scene set in a cave, there was some unspecified light that allowed us to see what was going on. The question then became, how big should that light be? Huge lights would undermine the feeling of being underground, but small lights could give every scale on the Dragon its own little highlight, creating a mess of detail.

That was why we created turntables, in which the character model was posed and rendered under different lighting conditions so that we could evaluate the results. It illustrates how closely Shaders and Lighting have to work together because we deal in the same currency.

Jed Wojtowicz, Weta Digital Shaders Supervisor

By contrast, the lighting of the forge battle in which Smaug is out for blood came predominantly from below, a hot, fiery under-light, casting dramatic spiky shadows and making him look even more monstrous and psychotic *(right)*. In both sequences we were lighting according to the state of Smaug's mind.

Eric Saindon, Weta Digital Visual Effects Supervisor

The glow in Smaug's eyes helped when he was lit in silhouette because we could still tell where he was looking. Similarly, the glow of his chest was something we could use to help define and carve the architecture of his head, meaning we didn't always have to hit him with a light in order to read his face.

Miae Kang,
Weta Digital Lead Lighting Technical Director

Gollum was the first character I worked on at Weta Digital as a Creatures Supervisor more than a decade earlier. It was so fun to come back to another big digital character on these movies and get back into a full character with a personality, as opposed to creatures, it was like coming full circle.

Eric Saindon, Weta Digital Visual Effects Supervisor

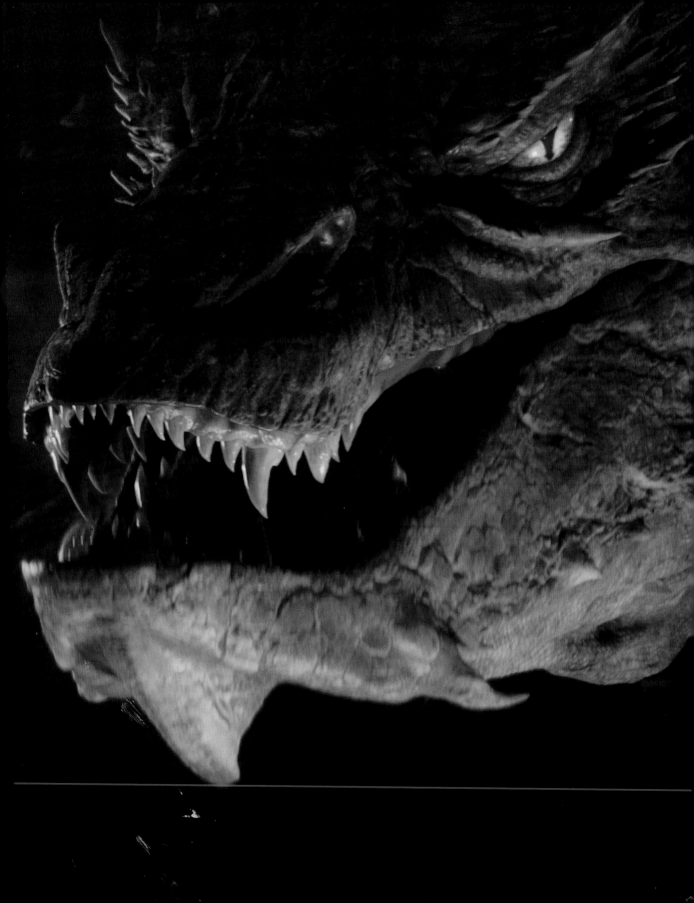

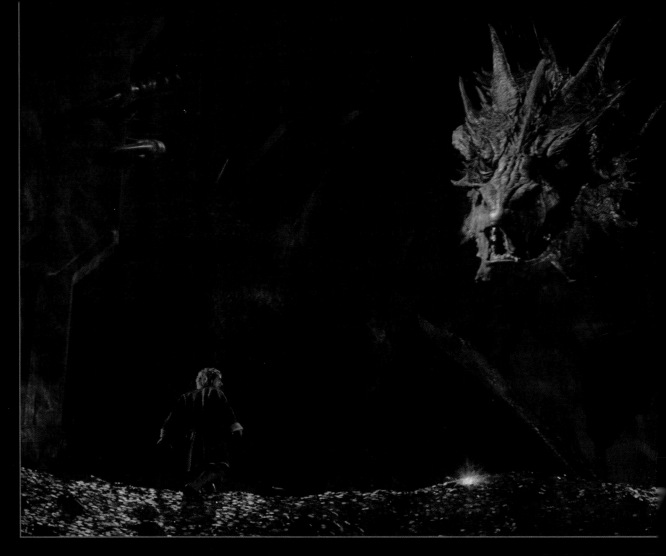

THE SCRAPE OF CLAW ON STONE

Smaug's claws were ever-present events that were tricky to place around the dialogue. Often his claws would set down right on top of a line. They had to convey his massive size and weight, but not get in the way of the conversation. When we were in the scenes that included treasure, the solution was to keep them sonically deep, while the treasure impacts and movements were in the high-mids and high-end frequencies. This usually left a lot of room in the sound spectrum for the dialogue to fit, whether it was Bilbo or Smaug doing the talking, but sometimes we still had to drop the volume of the claws. In the early stages, before the animation was complete, I tried placing the claw sounds only between the dialogue lines, hoping that animation might follow what we were doing with sound. In some cases that did

work, but not always. Eventually, when the shot was completed, we had no choice but to move our sounds to be in sync with the picture.

Later in the film the action moved out of the treasure area and Smaug was walking on solid stone. During his visual effects reviews Peter was quite specific about wanting Smaug to put the heel of his claw down first, so I took that as a sonic direction as well. There was usually a solid heel strike, which was made up of a combination of log and rock impacts. For the actual claw tip contact, I did a series of recordings using elk and deer antlers on various dirt and stone surfaces, combining those with the impact sounds to make it a bit more complex and to match the imagery.

SOUND DESIGN

The title Sound Designer has many forms these days. For me I'd say I have one of the most enjoyable positions on the Sound crew as creative supervisor. Generally I am tasked with working with 'hero' events, like Smaug, or Gandalf's magic, but it can also be subtle sounds like the gentle voices the Ring puts in Bilbo's head, or what Ring-world sounds like. Sometimes I generated a library of sounds for other editors to work with, but I would edit and work with my own material to picture.

For the most part, I was given the freedom to come up with my own ideas for sounds, and then get Peter's reaction to them, similar to the way he might work with concept art. We were typically working on the soundtrack for temp mixes, which are works in progress to show the studio, long before the visual effects were in, and during the picture editing process as well. This would give us time to formulate our own thoughts about how well a sound was working and make adjustments as we went. Occasionally it worked out that we would have to change the approach very late in the process, so we would always try to be ready to change course quickly if that was needed. The trickiest part of this process was really working to visuals that were often in very early stages and only roughly animated. We could make our best guesses at what would finally match the picture, but often a sound would have to be changed, sometimes drastically, so that it 'stuck' to the image seen on screen. The best sound in the world won't matter if it's not correctly attached to what we see.

David Farmer, Sound Designer

Mostly, Smaug was just walking around inside Erebor, but his wings still played a part. As he walked, the leathery part of his wings would billow and spread, and even sparing use of these sounds really helped give us a sense of his size and presence. The wings were a combination of a canvas paint drop-cloth, that I had used for the fell-beast wings in *The Lord of the Rings*, and a rubber-coated tarpaulin that I found by accident one day when at Stone Street Studios. It was being used to cover up some huge piece of a set, and the ever-present Wellington wind was whipping it all around. I recorded that tarp, at the time not having any idea what I might use it for, but later it became an integral part of Smaug's wing presence.

David Farmer, Sound Designer

We were playing with the idea that just before Smaug starts to blow fire he might develop an inner heat. I liked the idea of him perhaps having an internal glow, so I threw in concepts where his nostrils had a glow deep inside them, then the thought was that his chest might inflate and glow. It would travel up his body, perhaps glowing through some parts before bursting out as a gush of flame from his mouth.

Gino Acevedo,
Weta Digital Textures Supervisor/Creative Art Director

The chest illumination was a great idea. In preparation for vomiting flame we would seal Smaug's lips and flare his nostrils as he inhaled. Whatever biology was going on inside him to produce the combustion, it took a bit to get going, which meant we could give it emphasis and make each blast a visually and dramatically satisfying event. It also gave the Dwarves and audience a visual cue, warning of an imminent burst of flame so they could believably seek cover in time.

David Clayton Weta Digital Animation Supervisor

When animating the Dragon breathing his burst of fire there was the tendency to do the obvious thing and animate it like a cobra striking. He would pull back, rearing upright, pause a beat or two as it built up, sucking in air and holding that pregnant pause before lurching forward to project his flame. We had probably done something like that a few too many times in our animation because suddenly Peter said he wanted something a bit less conventional, perhaps having him come from the side or without as much build-up.

Eric Reynolds, Weta Digital Animation Supervisor

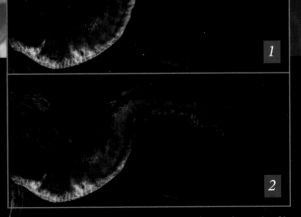

1: *Smaug's final chest glow effect in a frame from the film.*
2: *Test renders exploring how much of Smaug's chest might glow before breathing flame.*

DRAGON-FIRE

Leading the exploration of our fire effects on the second film of *The Hobbit* meant an intense few months! We had seen some of Smaug's fire-breathing abilities in the first film and didn't want the fire in the second to drastically depart from what had been established, but Peter also had some specific things he wanted to see, including the idea of Smaug's flames burning a projected liquid fuel of some kind.

We gathered imagery and video of large-scale fire that could be used as reference for us to match. We had a video of the Churchill Crocodile, a kind of Second World War flame-throwing tank which was very useful, because it was one of the few flame-throwing references we could find that had adequate scale. Most others were simply too small to be useful in understanding what fire looked like when projected at Smaug's scale. We were talking about something like 150,000 cubic metres of flame being thrown each time he blasted!

The liquid quality to Smaug's breath helped distinguish it from the fires of the Dwarf furnaces, which was coal, or, when Bombur was pumping the bellows, gas-fuelled. Smaug's combustion was fundamentally different. We actually simulated the petrol-like fuel component with particles which gave it a physicality that was absent in the more conventional Dwarf furnace fires. It also allowed us to shape where we wanted the fire to be, and have a good idea of how it would propagate and spread without having to fully render it. Normally, if we wanted a lot of detail we might sometimes be waiting days for a result to be simulated, only to decide it needed to change, so the liquid fuel component sped things up for us

Adrien Toupet, Weta Digital Lead Effects TD

There was an explosive element to the fire that came from it being based on a burning liquid. When it would hit surfaces it would splash and explode, which was a really aggressive effect and just what Peter was after.

Mathieu Chardonnet, Weta Digital Senior Effects TD

We could also take that liquid and stick it on anything that needed to have fire on it, like Thorin when he just escaped being burnt. Smaug's fire had to propagate up walls and along surfaces, so we tried to keep it alive as long as we believably could and not just have it burn itself out quickly. It chased the characters as it roiled in advance of the Dragon, something Peter was quite specific about wanting to see.

In some shots we didn't have fire emerging from Smaug's mouth, but we still had a heat haze that would suggest his breath was intensely hot.

Peter also wanted a clearer patch of flame at the point where it was first emerging from the Dragon's throat, so we created a blue gas effect, similar to what you might see when looking at a candle.

Adrien Toupet, Weta Digital Lead Effects TD

There was a chemiluminescent reaction that occurred at the beginning of the combustion phase in Smaug's mouth. In reality that's when we see all the greens, blues or purples in a flame. It's essentially how astronomers are able to determine the chemical components of a star. We didn't want Smaug's flames to be purely some kind of napalm incineration effect, so a hint of blue flame occurring just prior to full combustion was a nice little extra element to set it apart.

Jed Wojtowicz, Weta Digital Shaders Supervisor

EFFECTS

In Effects we do what can't be done by other departments – what can't be painted, or modelled. We handle the atmospheric effects, fluid simulations, fire, rain, cloud, explosions, smoke, magic and all those other intangible elements that fill out a scene to make it feel real. We often begin work early, testing out different effects to find a look that suits what the director is looking for, but we usually can't do our final work until we have completed animation, because if we are simulating fire being breathed by Smaug, for example, and Smaug's animation was to change, then our fire wouldn't be coming from the right place anymore. For that reason we tend to be working at the end of the process. We would work closely with the Lighting guys, especially on this film because there were scenes they were working on with interactive lighting coming from the glow of the fire we were simulating. They would have to wait for us to provide the fire before they could render the firelight.

Mathieu Chardonnet, Weta Digital Senior Effects TD

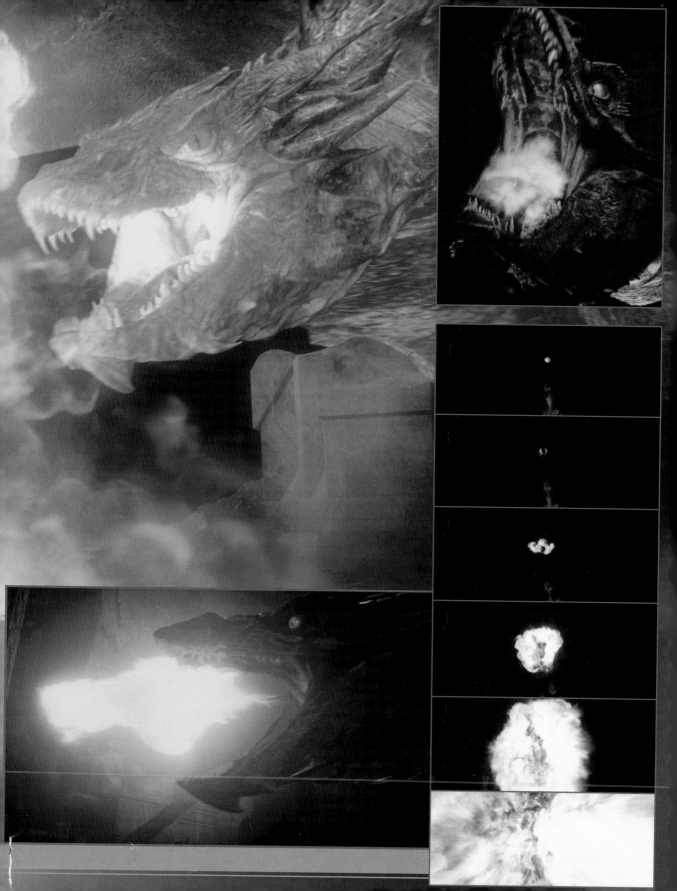

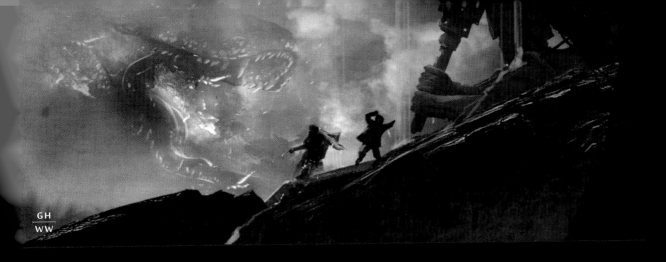

FIGHTING FIRE WITH FIRE

Peter, Fran and Philippa knew they needed some kind of climax in which Thorin and Smaug would come face to face, a scene that did not occur in the book. The Dwarves of Middle-earth had been established as craftsman and inventors, so it stood to reason that deep inside their mountain stronghold were the facilities that drove that industry, the forges of Erebor. The filmmakers felt that the answer to their missing climax was to be found here. Thematically and narratively, there were some great convergences, but also an opportunity to stage the confrontation on a scale worthy of cinema.

With the broad story strokes of what was needed in his head, Peter put together a series of creative think-tank meetings to help conceive the film's climactic moments in more detail. Christian Rivers, Jamie Beard and Marco Spitoni from Weta Digital's previsualization team were there, along with Concept Art Directors Alan Lee and John Howe, while from Weta Workshop we had some of our core design team plus Ben Hawker, who has a great feel for cinematic storytelling.

Over a series of meetings and three weeks of workshopping, animating and illustrating ideas the seeds of a sequence began to evolve: Erebor was Thorin's home and he knew it well. Taking full advantage of every trick he could think of to stall or entangle his foe, the heir to the kingdom would lead the Dragon on a chase that saw the ancient forges reignited and ultimately save them all, though at a terrible cost.

Daniel Falconer, Weta Workshop Designer

The forge battle formed out of metaphor: fighting fire with fire. How would Dwarves mount any kind o defence against something like a Dragon? They needec something of adequate scale to be remotely effective Perhaps they would make use of machinery they would ordinarily use for mining and crafting? Maybe they could lure or provoke Smaug into a part of the Mountain where they can use his own flames to ignite the fires that power their machinery, and then turn tha on him?

We came up with a lot of simple gags that came out o the sessions we had. One was the notion of both Smaug and the Dwarves creeping around, playing a game o hide and seek within the tunnels, neither sure where the other is, when the Dwarves start seeing little coins tinkling from above and suddenly realize the Dragor is moving overhead. That began as a very simple littl animation offered up to express an idea and endec playing beat for beat in the finished film. Peter woulc take these germs of ideas offered up, pick his favourites and expand upon them, at which point we would begir the previsualization production stage, in which we worked back and forth with him to design the sequence he needed.

Christian Rivers, Second Unit Director - Splinter Unit
Weta Digital Previsualization Supervisor

PREVIS

With concept art the aim is to encapsulate the mood and feel of an idea. In the Previsualization (Previs) Department we are more concerned with the mechanics of certain gags and the physicality of how a certain moment might happen. We create simple animations that suggest how a given piece of action could play out. The two processes often work best when paired. Sometimes we would work up a piece of previs that Peter loved and he would have an illustration done to flesh it out, or vice versa: he might react to a piece of artwork by having our team work out parts A, B and C of the action suggested.

As the script is written, and taking cues from what occurs in the book, Peter, Fran and Philippa will have strong things they need characters to do, challenges or decisions they need to make. These usually aren't things we in Previs have anything to do with unless it is embedded in some kind of big action piece. Usually we are filling in the material going on around those key moments, such as what the various Dwarves are doing to try to fight back against Smaug.

The script will typically say something like, 'And they fight,' at which point it might fall to us to come up with ideas to fill the next minute with unscripted action. We represent the first stage in the process of throwing together moving visuals. We try to be story-focussed, although generally we don't influence critical turning points for characters in the story. That really is the province of the writers. We tend to be coming up with gags that are situations in which a complication arises and characters have to resolve it. At the cheap

end of the spectrum the answer is that the character was lucky and got out of situations through their good fortune, while at the more involved end something was revealed about the character – he's smart or he's cool under pressure, or amazing with his weapons.

Sometimes Peter has a very good idea of what he wants from us and typically those are the ideas that end up in the film, but he is the kind of director who leaves no stone unturned and he will use previs to explore all options. He never wants a sequence in one of his films to simply be the first and only thing he thought of. He likes to workshop ideas and see every variation or option first before deciding on what will work best for the spectacle he has in mind. He will involve the Previs Department, or John Howe and Alan Lee or sometimes Weta Workshop's designers as well. In the case of the forge battle with Smaug, he convened a series of brainstorming meetings with everyone.

When we began previs for the Smaug sequences we didn't have a locked-down design. We didn't even know how big he was. It meant we were guessing, but at the same time previs is also a good place to answer those sorts of questions. Peter could make up a number and say Smaug is this big, but actually putting him in situations and trying to rough out action, shots and sequences he could quickly appreciate what size the Dragon needed to be to work on the screen. His size could be locked down with some confidence because he was seeing him in context.

**Christian Rivers, Second Unit Director - Splinter Unit /
Weta Digital Previsualization Supervisor**

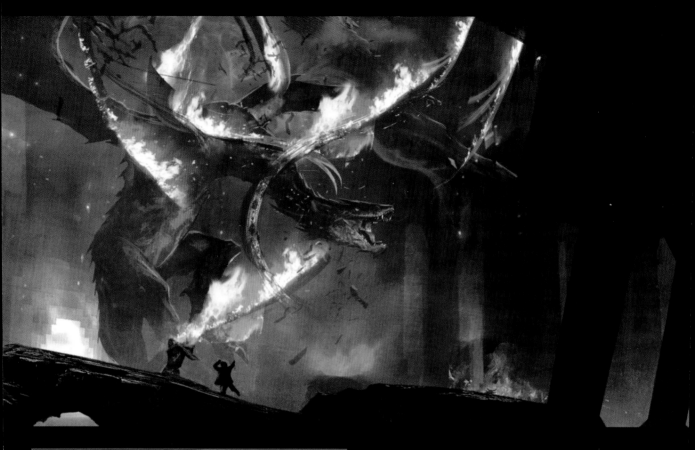

Philippa had the notion of the Dwarves fighting fire with fire, and from that came the idea that the Dwarves would use Smaug's own flames to light the forges and turn them against him.

I began my explorations of the sequence by looking into what the mood and palette of the forge area might be. Perhaps sudden bursts of steam could provide a way for the Dwarves to escape from him realistically?

The chase that emerged was a cat and mouse game, but we imagined the Dwarves might also try to lure him into places where they think they could hurt him. The Dwarves really had no hope of killing him, just slow down or briefly entangle him, buying time for them to get away, either with chains and ropes or using the tapestries. I thought that could be a very striking visual, seeing huge, long Dwarven tapestries on fire, wrapped around him as he struggled *(above)*.

Though it wasn't picked up, I liked the idea of a huge bell, like a giant cathedral bell, that the Dwarves would ring and could be used against Smaug *(facing page, bottom)*.

Gus Hunter, Weta Workshop Designer

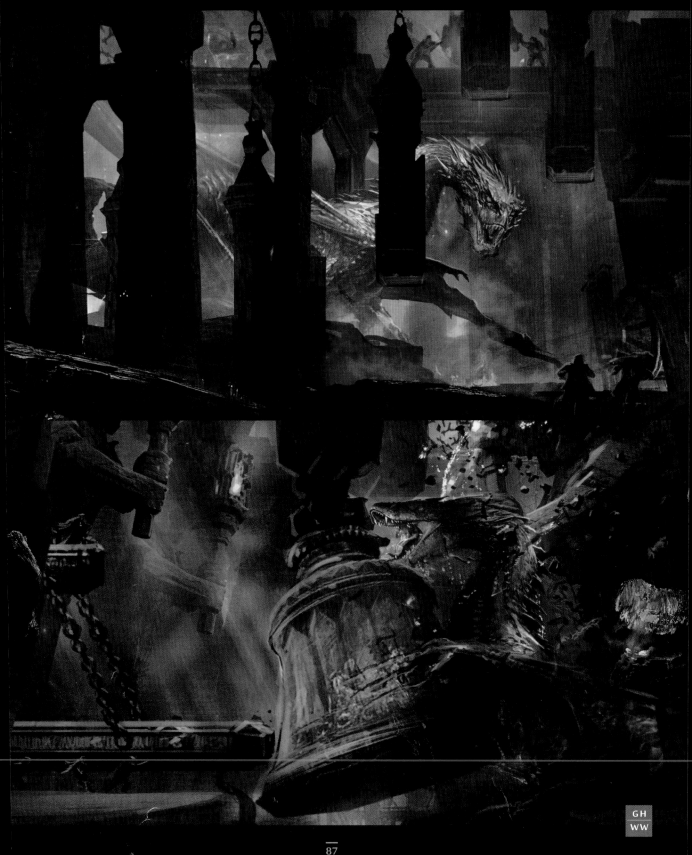

GT
WW

I was really keen on finding as low tech a solution to the problem of an automated Dwarf mine and forge as possible. Water wheels made a lot of sense as a source of energy to start the machinery moving and required no explanation; with the River Running established flowing out of the Mountain we had it right where we needed it. Hydro-power was an obvious choice and could be 'switched on' with the opening of a water gate or the engaging of a cog, something any of our Dwarf heroes could do.

We talked about the visual of a character such as Bilbo being chased by the Dragon through an area where water-driven rock-crushers carved into hammers wielded by giant Dwarf statues might come crashing down, one after another.

Greg Tozer, Weta Workshop Designer & Sculptor

Once the forges were alight we imagined the whole place would come to life and we'd see buckets of hot gold or other metals moving around, perhaps giving the Dwarves places to hide *(right)*.

I loved the idea of Erebor being full of huge statues. Maybe they'd line a corridor down which the Dwarves might ride, hiding in buckets? Having giant Dwarf effigies that are the same sort of size as Smaug was a neat idea. The Previs Department suggested having the giant faces illuminated by fire. Everywhere Smaug looked he would see monumental Dwarf faces glowing back at him and he might take out his rage on them, tearing them down.

Gus Hunter, Weta Workshop Designer

I offered the idea that the miners might use giant swinging hammers which they could adjust for height and angle to smash big chunks of ore and rock out of the face of their mineshaft. I imagined that Thorin and his Company might lure Smaug into the path of one of these massive hammers using someone like Bilbo or Bombur for bait. They would have the hammers cued up and, as soon as the Dragon was in the right position, let them go *(facing page, bottom left)*. It was a simple idea, a hammer on a chain, but I thought it could be very nasty and even potentially fatal – a believable way for the Dwarves to take him on.

Greg Tozer, Weta Workshop Designer & Sculptor

I imagined more of a simple delaying action and something that the Dwarves could pull off without the need for an elaborate set-up. I came up with the idea of the Dwarves breaking terracotta urns as they sprinted by, spilling great quantities of lamp oil and thereby creating a slick to slow down Smaug *(facing page, bottom right)*. Erebor was a vast place filled with lanterns and torches, so it made sense to me that they would have huge stores of oil.

In conversation Peter took it a step further, adding the idea that Smaug might turn the tables on the Dwarves and ignite the oil and imperil them.

Paul Tobin, Weta Workshop Designer

We took the ideas for the Erebor forges confrontation to a certain point before it was shelved in order to give Peter time to mull it over and orchestrate how he wanted it to play out in the context of the film's last act. When he was ready to proceed again it went straight to the animators rather than coming back to us again to finesse. They threw their gun animators at it and knocked out some impressive animation that wasn't finished, but was taken far enough that Peter could start crafting shots around it. The intricacies of the scene as it turned out in the end were much more complicated, but the bare bones of what made it into the film is essentially what we came up with months and months earlier during our Erebor forges think-tank.

Christian Rivers, Second Unit Director - Splinter Unit /
Weta Digital Previsualization Supervisor

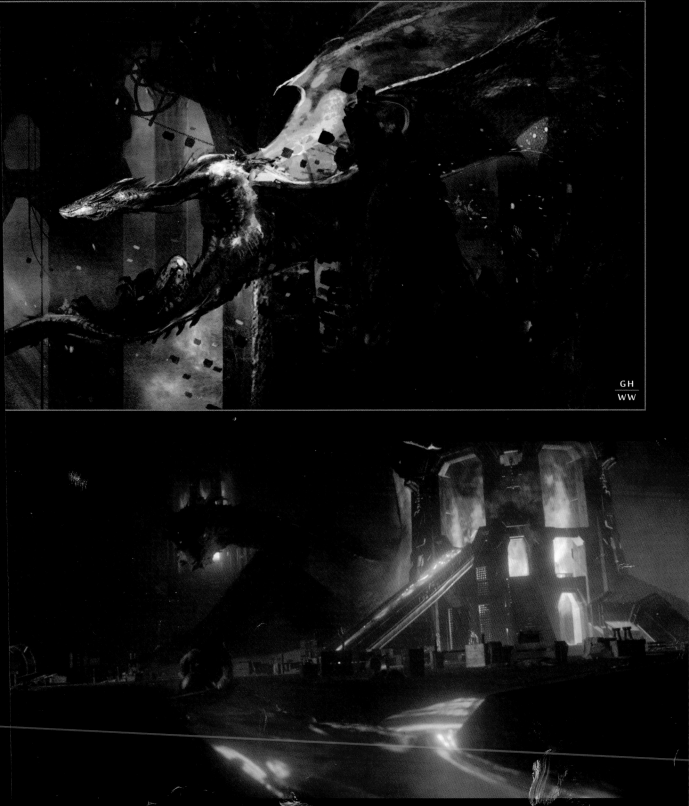

GH
WW

The way Peter designed and shot the forges sequence set in place a new way of working for us. As always, it began with Peter and the Previs Department working through some basic ideas. Some long sequences of action came to us to animate, with Smaug smashing his way through to get at the Dwarves. We turned these around and sent them to the motion capture stage where Peter could watch the scene play while he moved around in the space and filmed that digital action with a virtual camera. He was standing in an empty room, but he could walk around inside the animation we had provided as if he was there with his camera and choose to film it however he wanted.

If Peter wanted to, he could specify a scaling ratio, so each step he took on the stage might move him twenty feet in the virtual space he was seeing through his camera, or put him up in the air for the equivalent of a crane shot. As he moved around in the space, watching the animation play out in front of him, he could freeze it at any point, find and frame up his shot from any angle he would want, and then record as if he were filming it on a live-action set. The animation was only taken far enough for what Peter needed at that point. If there were bits that weren't working for him he'd find a different bit of the animation that worked, set the camera and still get the action that he needed.

This was a great way for Peter to work and achieve the storytelling he had in mind in a way that was much more like shooting live-action, where he can react to what he is seeing and find the best shots to tell his story. What we provided him with was the broadest possible scope to do that. Before, he would have camera set-

up ideas and action that the Previs Department and our animators would send to him, but they weren't anything he could cut with or help him set the pacing of the scene. The chunks of animation we gave him for this sequence took a month to create, which ate into our time considerably, but the beauty of it was that once Peter had done his work on the mo-cap stage we had the exact shots he wanted, the exact length and there would be no need for notes on camera work or any of those back and forth processes which we would ordinarily have gone through. We skipped that entire part of the old process, so from then on it all went much faster.

Eric Reynolds, Weta Digital Animation Supervisor

The process wasn't necessarily new, but it was the first time Peter was able to use it as part of his filmmaking process. It just makes sense. You would never expect a director to shoot their live action material by proxy, having someone else second-guess what he wants and shoot options remotely to present to him for review, so why shoot digital material that way when you can give him the camera and let him find the shots he needs? There were so many advantages to it that I think it will be something he will do more and more of in the future.

Christian Rivers, Second Unit Director - Splinter Unit / Weta Digital Previsualization Supervisor

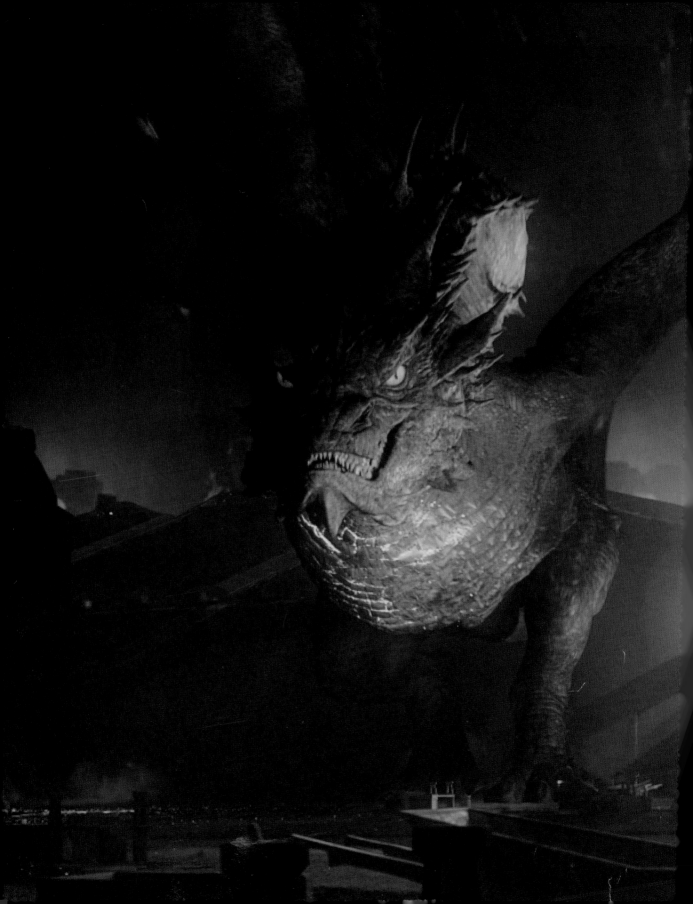

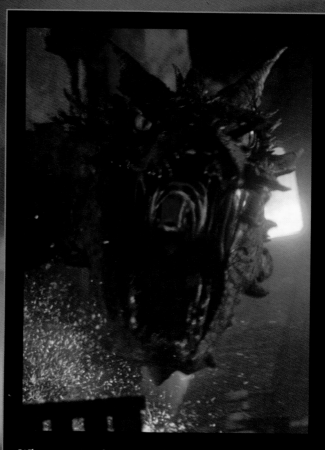

When moving him around we tried not to just have Smaug walk on flat ground because that was boring. He looked so much better when he was grabbing with his fore-claws and using the walls and columns of his environment to haul himself through with big, powerful movements.

At one moment during the forge battle Smaug was blasted with water and freaked out, flying up into the air and crashing far away from the Dwarves to shake it all off. Now he was enraged and came at them like a locomotive, low to the ground and nothing could stop him.

We had four or five shots of him coming closer and closer, and each step he took was huge. The forge area was a massive set piece, but the Dragon was simply so huge himself that it still only took him two or three strides to cover that ground. We had to pull the old movie gag of pushing him further back between shots as he advanced on them or he would have been on them too quickly!

Eric Reynolds, Weta Digital Animation Supervisor

THE MOUNTAIN KING'S RETURN

We were coming up with ideas for action and interesting moments in the stand-off between Smaug and the Dwarves and Bilbo. It was all building towards some kind of climax which we still didn't have. Smaug was such a vast creature that almost anything the Dwarves could try to do to hurt him would likely be fruitless, so most of the ideas we were coming up with were things that might buy them time and keep them alive, delaying the Dragon while they hid or moved.

I was thinking about what the various processes might be in lighting the furnaces of Erebor and what function they had when I came upon the idea that perhaps before the city had been deserted the Dwarves who lived there had been in the middle of casting a giant statue of King Thror. My thought was that Thorin and his Company might re-start that process, the forges would come alight and metal would be melted, pouring through various streams into the top of a huge iron-clad figure, the mould for the statue of Thror. Perhaps Thorin would entice Smaug to take a swipe at him, perching on the precipitous part of the structure and as he leapt to safety in the nick of time the Dragon's claws would rip open the casing, spilling the molten gold from inside, which would pour out and scald him. Everyone seemed to like the idea as it offered a suitably epic climax for the sequence and the movie.

Alan Lee, Concept Art Director

The molten gold statue of Thror felt thematically appropriate and made sense as something that could conceivably drive the Dragon out of the Mountain as well. Additionally, it's exactly the kind of thing Thror would do – erect a giant gold effigy of himself. I joked with Peter that it was a shame we hadn't come up with the idea earlier and could have set it up somewhere in the prologue of the first film.

Christian Rivers, Second Unit Director - Splinter Unit/ Weta Digital Previsualization Supervisor

We had to accept a little artistic deviation from reality in order to sell the story without a lot of explanation. It had to be obvious to the audience that Smaug was coated in gold. We spent time studying what gold looks like at different temperatures to understand what we were trying to recreate, and essentially hot gold looks like lava – glowing red and yellow with black looking slaggy stuff floating on top – so our initial tests were glowy with hints of darker, cooled gold, but it just never quite looked that good. Peter didn't want it to look like the Dwarves were pouring lava on Smaug so over time we settled on an effect that looked much more like liquid gold rather than super-heated gold, not necessarily strictly realistic, but narratively simpler. There was a hint of heat glow in there to help make it clear that the statue was hot and not just wobbly, but that was it.

Jed Wojtowicz, Weta Digital Shaders Supervisor

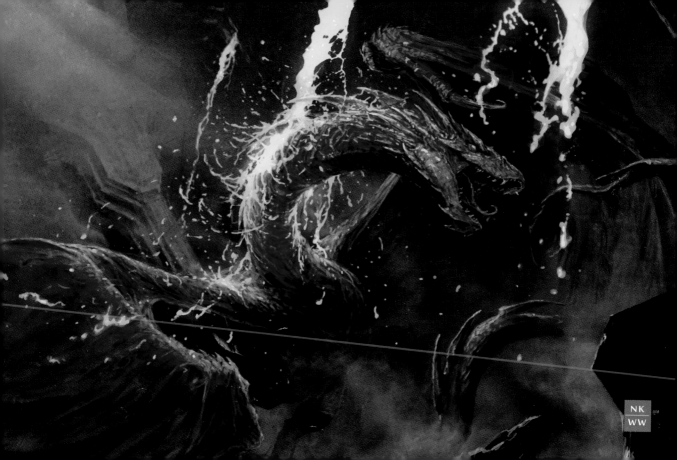

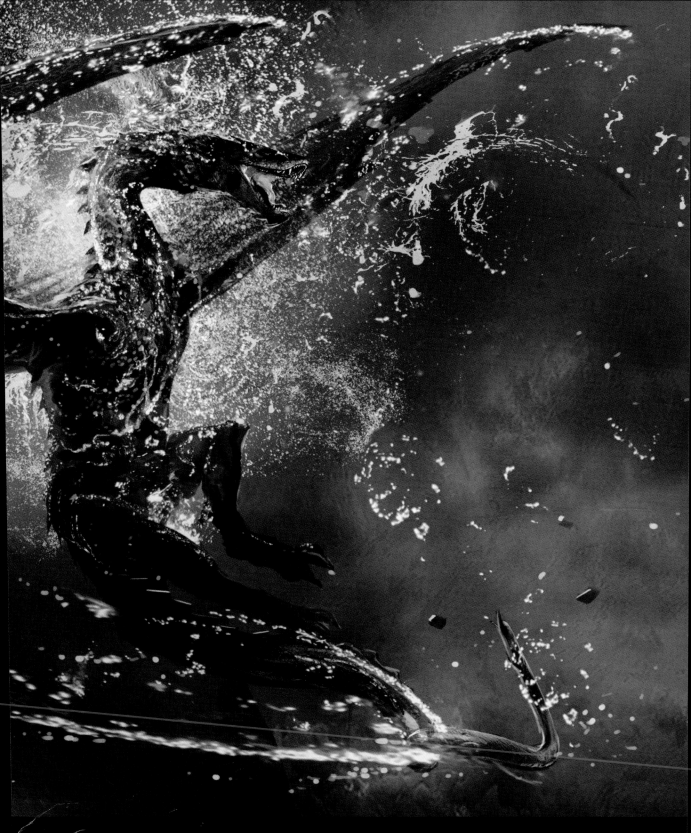

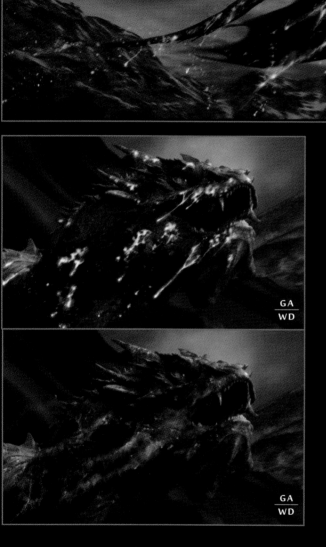

GA
WD

GA
WD

GA
WD

GA
WD

I created concepts trying to show how Smaug could still have some of the gold left on him, encrusted into his scales as we came into the close-up. In the wider shot, I thought there could be trails of smoke coming off of the still-molten gold as it was cooling.

Gino Acevedo,
Weta Digital Textures Supervisor/ Creative Art Director

Having erupted out of the Mountain in a bundle of rage like a stuntman on fire, the ascending spin Smaug did was akin to someone rolling on the ground to put out the flames. In our first animation passes we had him coming out and essentially flying straight off towards Lake-town. It was Peter who said, 'I think we need a quiet moment in here,' and that's where that move came from. We had just witnessed all this chaos inside Erebor, but once Smaug flew out Peter gave the audience a moment to catch their breath again. Smaug gathered himself in that moment, flicking gold everywhere as he climbed into the sky, clawing his way upward in a way that we were mindful had to convey an adequate sense of mass and power, then, free of the gold, he set his sights on his new prey, Lake-town.

Michael Cozens, Weta Digital Animation Supervisor

Smaug burst out of the Mountain and spiralled up into the night sky, shedding gold in an effect that Peter described to us as looking like a Catherine wheel firework. We used a much bluer lighting scheme so that the shots registered as being outside at night. We cheated the lighting of the gold so that it was brighter as it flew off him and then dimmed as it fell away.

Eric Saindon, Weta Digital Visual Effects Supervisor

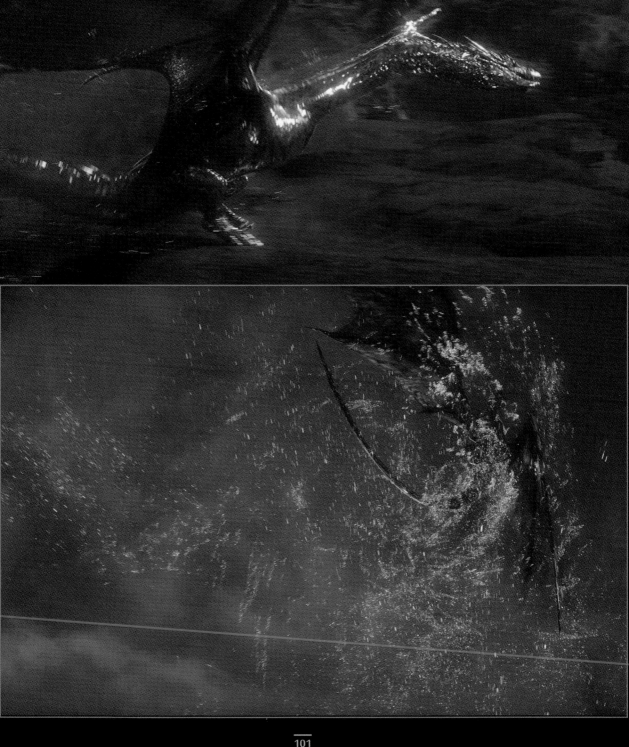

> "HAVING SHAKEN HIMSELF FREE OF THE MOLTEN GOLD, SMAUG FLEW OFF INTO THE NIGHT, BENT ON AVENGING HIMSELF UPON THE PEOPLE OF LAKE-TOWN."

In the final moments of the film, having shaken himself free of the molten gold, Smaug flew off into the night, bent on avenging himself upon the people of Lake-town. In his wake Bilbo was left stunned and consumed by fear and regret for what he had unleashed, and audiences desperate to know what would happen next. For that, however, they would have to wait till the next film, *The Hobbit: There and Back Again*, in which Smaug's ultimate fate and that of all our heroes would be told.

Eric Saindon, Weta Digital Visual Effects Supervisor

Contributor Credits

Writer and Art Director	Daniel Falconer
Layout Designer	Monique Hamon
Transcriber	Fiona Ogilvie
Weta Publishing Manager	Kate Jorgensen
Weta Workshop Design Studio Manager	Richard Athorne
Weta Workshop Design & Special Effects Supervisor	Richard Taylor
Weta Workshop Manager	Tania Rodger
Weta Ltd General Manager	Tim Launder
Photography	Steve Unwin Wendy Bown

HarperCollins*Publishers* UK

Chris Smith	Series Editor
Kathy Turtle	Production Manager
Terence Caven	Design Manager

Benedict Cumberbatch	Smaug

3 FOOT 7

Leith McPherson	Dialect Coach

PARK ROAD POST

David Farmer	Sound Desginer
Morgan Samuel	Assistant Dialogue Editor

WETA DIGITAL (WD)

Joe Letteri	Senior Visual Effects Supervisor
Adrien Toupet	Lead Effects TD
Alan Lee (AL)	Concept Art Director
Christian Rivers	Second Unit Director - Splinter Unit / Previsualization Supervisor
David Clayton	Animation Supervisor
Eric Reynolds	Animation Supervisor

Eric Saindon	Visual Effects Supervisor
Gino Acevedo (GA)	Textures Supervisor / Creative Art Director
Guillaume Francois	Senior Shader Writer
Jed Wojtowicz	Shaders Supervisor
John Howe (JH)	Concept Art Director
Kevin Sherwood	Visual Effects Producer
Marco Revelant	Models Supervisor
Mathieu Chardonnet	Senior Effects TD
Miae Kang	Lead Lighting Technical Director
Michael Cozens	Animation Supervisor
Myriam Catrin	Senior Texture Artist
Simon Clutterbuck	Digital Creature Supervisor

WETA WORKSHOP (WW)

Richard Taylor	Design & Special Effects Supervisor
Andrew Baker (AJB)	Weta Workshop Designer
Aris Kolokontes (AK)	Weta Workshop Sculptor
Christian Pearce (CP)	Weta Workshop Sculptor
Daniel Cockersell (DC)	Weta Workshop Sculptor
Daniel Falconer (DF)	Weta Workshop Designer
David Meng (DM)	Weta Workshop Designer
Gary Hunt (GJH)	Weta Workshop Sculptor
Gus Hunter (GH)	Weta Workshop Designer
Greg Tozer (GT)	Weta Workshop Designer
Jamie Beswarick (JB)	Weta Workshop Designer
Lindsey Crummett (LCC)	Weta Workshop Designer
Michael Asquith (MA)	Weta Workshop Sculptor
Nick Keller (NK)	Weta Workshop Designer
Paul Tobin (PT)	Weta Workshop Designer
William Furneaux (WF)	Weta Workshop Designer

Visit the Weta Workshop website for news, an online shop, and much more at **www.wetanz.com.**

ARTWORK CREDIT KEY

$\dfrac{AL}{WD}$

Artist credit as indicated on top and their department indicated beneath line

AL
WD

All artwork on page by indicated artist and department

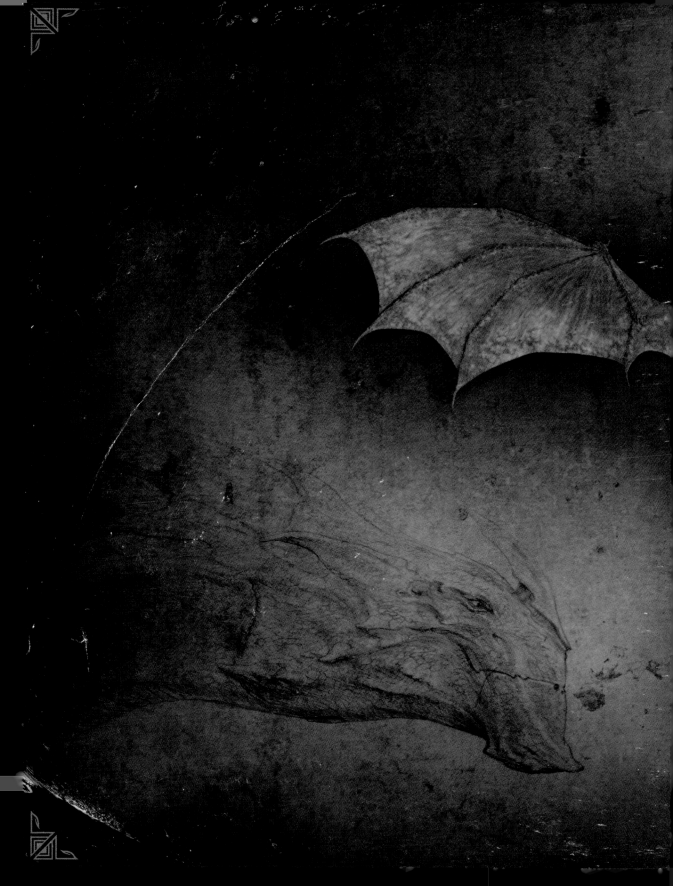